>> MNM

inside

mnm
minimalist interiors

inside

mnm

minimalist interiors

Edited by Nasple & Asakura

HDi

HARPER
DESIGN
international

An Imprint of HarperCollins *Publishers*

Publisher: **Paco Asensio**

Editors and Texts: **Nasple & Asakura**

Editor in Chief: **Haike Falkenberg**

Art Director: **Mireia Casanovas Soley**

Graphic Design & Layout: **Miguel Ángel Ramos López**

First published in 2003 by:
Harper Design International, an imprint of HarperCollins Publishers
10 East 53rd Street
New York, NY 10022

Distributed throughout the world by:
HarperCollins International
10 East 53rd Street
New York, NY 10022
Tel.: (212) 207-7000
Fax: (212) 207-7654

HarperCollins books may be purchased for educational, business, or sales
promotional use. For information, please write:
Special Markets Department
HarperCollins Publishers Inc.
10 East 53rd Street
New York, NY 10022

 Library of Congress Control Number: 2003112448

ISBN: 0-06-053611-X

DL: B-38.693-03

Editorial project

LOFT Publications
Via Laietana, 32 4 Of. 92
08003 Barcelona. Spain
Tel.: +34 932 688 088
Fax: +34 932 687 073
e-mail: loft@loftpublications.com
www.loftpublications.com

Printed by:
Anman Gràfiques del Vallès, Spain

First Printing, 2003

Beyond Minimalism	Intro by Nasple & Asakura	4
My Conception of Housing Design	Intro by Toyo Ito	5
Sakurajousui K House	Toyo Ito & Associates, Architects — Tokyo, Japan	8
Yutenji T House	Toyo Ito & Associates, Architects — Tokyo, Japan	16
Wall-less House	Takaharu and Yui Tezuka Architects + Masahiro Ikeda — Tokyo, Japan	22
Kamakura	milligram studio / Tomoyuki Utsumi — Tokyo, Japan	32
House in Senzoku	milligram studio / Tomoyuki Utsumi — Tokyo, Japan	42
Schär-Valkanover House	Blum & Grossenbacher — Grossdietwil, Switzerland	50
Ai Wei Wei's House	Ai Wei Wei — Beijing, China	58
Casa A-M	Elena Mateu Pomar — Barcelona, Spain	66
Alexander Residence	EOA / Elmslie Osler Architect — New York, USA	74
Dirty House	David Adjaye - Adjaye / Associates — London, UK	80
Picture Window House	Shigeru Ban Architects — Tokyo, Japan	90
Gillett Klinkowstein Residence	EOA / Elmslie Osler Architect — New York, USA	100
Subaek-dang	Seung, H-Sang / IROJE architects & planners — Seoul, South Korea	110
Two Houses in San Diego	Sebastian Mariscal / MS-31 inc. — San Diego, California, USA	118
The Shared House	Kanika R'kul / Leigh & Orange (Thailand) Ltd. — Bangkok, Thailand	124
Casa Sala	Tonet Sunyer — Barcelona, Spain	134
Ryan Apartment	PTW Architects — Sydney, Australia	142
Stein-Fleischmann House	Jacques Moussafir / Moussafir Architectes Associés — Paris, France	150
House in Madrid	J. Torres Vérez / a-cero estudio de arquitectura y urbanismo, s.l. — Madrid, Spain	156
Loft A	Carlo Donati — Milan, Italy	164
House in Fukaya	Waro Kishi + K. Associates — Kyoto, Japan	170

Beyond

M
b'
A

Initially, the term Minimalism became a sign of the times among those who were victims of the excesses of consumer society. The word came forth in the 1960s in the United States, when renowned artists, such as Donald Judd and Robert Morris, first considered the concept. In architecture, the book Minimum, published by the British architect John Pawson in the 1990s, exerted a strong influence in the design world. It signified a rediscovery of the minimalist movement. Other architects such as Peter Zumthor, Herzog, and de Meuron were also considered minimalist architects. However, among the western media, there appeared to be some sort of confusion between minimalism and modernism. An example of such a borderline style was Mies Van der Rohe's celebrated style that "Less is More." Is Mies also a Minimalist?

According to John Pawson, the key elements of Minimalism are the soul, the light, the "being in order," and reiteration. It is interesting to note the important influence that traditional Japanese and Asian spaces exerted in Pawson. Once having decided to be a Zen monk in Kyoto, he changed his mind and decided to be an architect, after becoming acquainted with the renowned Japanese designer Shiro Kuramata.

For this book, we have specially commissioned Japanese architect Toyo Ito to write an introductory article about his work and Minimalism. –Ito is one of the most innovative and influential architects in the world today. As winner of the 2002 Golden Lion Prize at the 8th International Architecture Exhibition of La Biennale di Venezia, we is recognized for his distinguished and valuable contribution to contemporary architecture. According to Toyo Ito, there is a clear difference between Minimalism and Modernism. For Ito, Minimalism basically does not pursue functionality. It is interesting to note that when the famous American artist Donald Judd was interviewed late in his life and asked whether he considered himself a Minimalist, his answer was that he did not want to be called a Minimalist nor his works be put into the Minimal Art Group.

Similarly, most architects who have collaborated and are being featured in this book would rather not be termed as Minimal architects. However, should we consider Minimalism in a wider scope, as representing sophisticated yet simple spaces, incorporating the most advanced techniques, and being more "site specific" (meaning to do the best in each particular situation, or to react reasonably to a particular surrounding), we could then think of all architects´ published work in this book as being Minimalistic. Their work also succeeds in the elimination of any unnecessary ornamentation in order to create the simplest space after having absorbed different kinds of information and choices, as well as for their geometrical purity.

However, just creating a simple space is not the answer. For instance, although the Japanese Zen Garden may be an ideal example of Minimalism, just imagine if the renowned Ryoanji Zen Garden in Kyoto were made of concrete and glass, instead of just white sand and carefully chosen trees. The famous phrase "Less is Bore," coined by Robert Venturi, could then perfectly apply. A simple space should thus be created with the fullest energy that provides our imagination. In this technological and excessive materialistic "network society" the key consideration lies in deciding what is really essential for living, and to be able to adopt modern life with a few carefully selected belongings.

In this book, our hope is to introduce you to some of the most renowned and emerging architects from different parts of the world, whose architecture represent a genuine cutting-edge challenge and an innovative way to lead our future way of living.

Beyond Minimalism

by Nasple & Asakura

My philosophy of designing residential houses divides roughly into approximately three periods. Were I to summarize their connotations, they could be described as the period of Minimalism of the 1970s, the period of Primitivism of the 1980s, and finally, the period known as Practical Realism or matter-of-fact period, ongoing from the second half of the 1990s to the present day.

My work, White U (1976) symbolizes this first era of Minimalism. The piece has a simple, horseshoe-shaped form, totally white inner spaces with extremely limited openings, the feeling of being in a basement space with natural light coming only from the upper part, and just one Mackintosh chair placed allegorically under a ray of light. Unfortunately, after a life span of 20 years, the White U House no longer exists.

The task I was trying to accomplish with this project was far distinct from the ideological concept of the Western Modernism of the early 20th Century. The reason being was that the space of White U House was created by a binomial confrontation between both the centripetal character and the circulation desire of its inner space, a contradiction made on purpose that provoked a continuous circling around the core of the house without ever reaching its center, thus creating emptiness. To achieve hollowness or emptiness was exactly the aim when designing this residential project. At the same time, though, it was one of the factors that led to it being demolished after 20 years. The idea of circulating forever around the naught (nothingness) was heading in the opposite direction of Western Modernism's search to basically pursue simple clearness and lucidity through function.

The second era is symbolized by my work known as Silver Hut (1984). In this house, the various views of the vault roof reminds us of a primitive settlement. The vault roof, supported by plane truss, was set on a self-supported concrete pillar, with a courtyard covered by an awning and kawara roof tile paving its floor. The openings are made out of recycled automobile parts, thus, as in ancient times when people went into the forests to pile up wood to build their huts, today's human beings finish up their own huts with the elements and recollected material from another urban forest, in this case Tokyo. At this point, its inhabitants became "urban nomads."

From the Minimalism concept of the 1970s, I was looking for the beauty of nothingness and the emptiness amidst the chaotic world of that time. As with the concept of "urban nomads" of the 1980s hanging around the "consumer city," the conceptual conversion that took place in my approach to house design is best symbolized by the mere change of the city of Tokyo itself during these years.

During and after the mid 1990s, and with the end of the bubble economy, the city became more and more gently introverted. People tended to look at themselves in more realistic terms, looking at their daily life simply as it was, without the past exaggerations of the 1980s.

In this context, the time to search for symbols in architecture was over. In accordance with this change, my residential projects turned into more "matter-of-fact aspects." At one time, some materials such as aluminum or steel were used as substance to obtain such special effects as lightness, airiness, and anti-ordinariness in general. Nevertheless, today I regard aluminum as nothing more than aluminum. Exactly in the same manner, I have no intention whatsoever to place any special meaning on glass and concrete either.

The meaning of my architecture and the objectives I pursue when confronting housing design is to provide a calm support "for the human body" and to procure a natural and relaxed space for people to live.

»Text translated from the original Japanese text by Jaume J. Nasple

My Conception of Housing Design
by Toyo Ito

Sakurajousui K House

Toyo Ito & Associates, Architects
e-mail: mayumi@toyo-ito.co.jp

Completion date: **2000**
Location: **Tokyo, Japan**
Floor Space: **1174 ft²**

Photographer: **Tomio Ohashi**

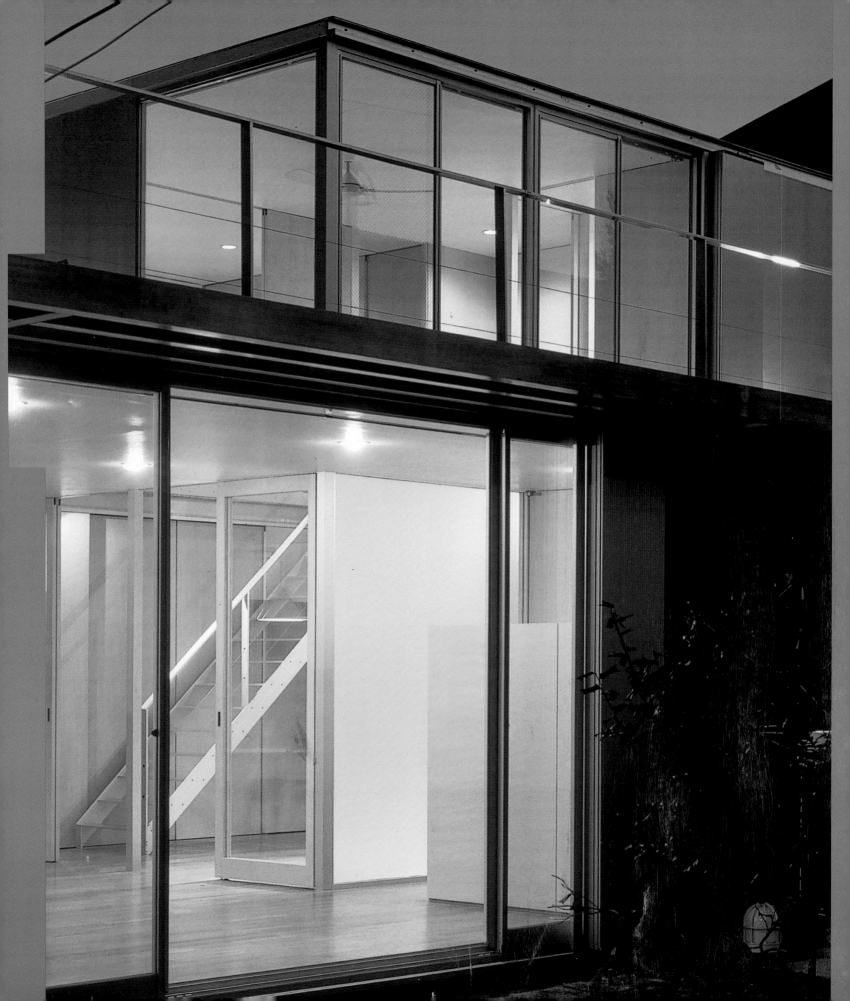

Born in 1941, Toyo Ito graduated from the Tokyo University department of Architecture in 1965. After a brief time of working for Kiyonori Kikutake Architect and Associates, Toyo Ito set up his own studio, "Urban Robot," in Tokyo in 1971. In 1979, the name of the firm changed to its present one, Toyo Ito & Associates, Architects. The architect created the basis for new concepts of life in large population centers with his renowned domestic constructions, "White U"(1976), and "Silver Hut"(1984). He also developed the vision of large mobile-city communities with the "Pao Projects," such as "A dwelling for a Tokyo Nomad Girl" (1985). His most recently acclaimed project, "The Sendai Mediatheque," completed in 2001, is a powerful work where Toyo Ito lucidly demonstrates his enthusiasm for impermanence and ambiguity.

Sakurajousui K House, located in Tokyo, was built for a married couple, the project being a totally experimental aluminum house. As the result of long research with engineers, the aluminum house ended up achieving a more delicate space than the usual structures built in Japan with the use of reinforced concrete. Since a space composition similar to a wooden structure was also possible to conceptualize, according to Toyo Ito, the aluminum house is quite suitable as a small residence. One should pay close attention to its unified finish and structure.

Toyo Ito, when designing this project, had a feeling that he was approaching more the field of industrial product designing, like designing vehicles, rather that doing pure architecture. The weak point of the project, argued Ito, is the challenge of soundproofing. Although some improvements could be made in this respect, the architect contends that there is great potential in aluminum housing. It is recyclable, lightweight, and easy to assemble, therefore quite appropriate to use as temporary housing for refugees in disaster areas, or to be used to build an annex on the roof or a terrace of a building. Compared to the wooden structure of a Japanese house, it is more open and airy. Toyo Ito maintains that one of the new prototypes of housing systems available in the future should definitely be the aluminum house. «

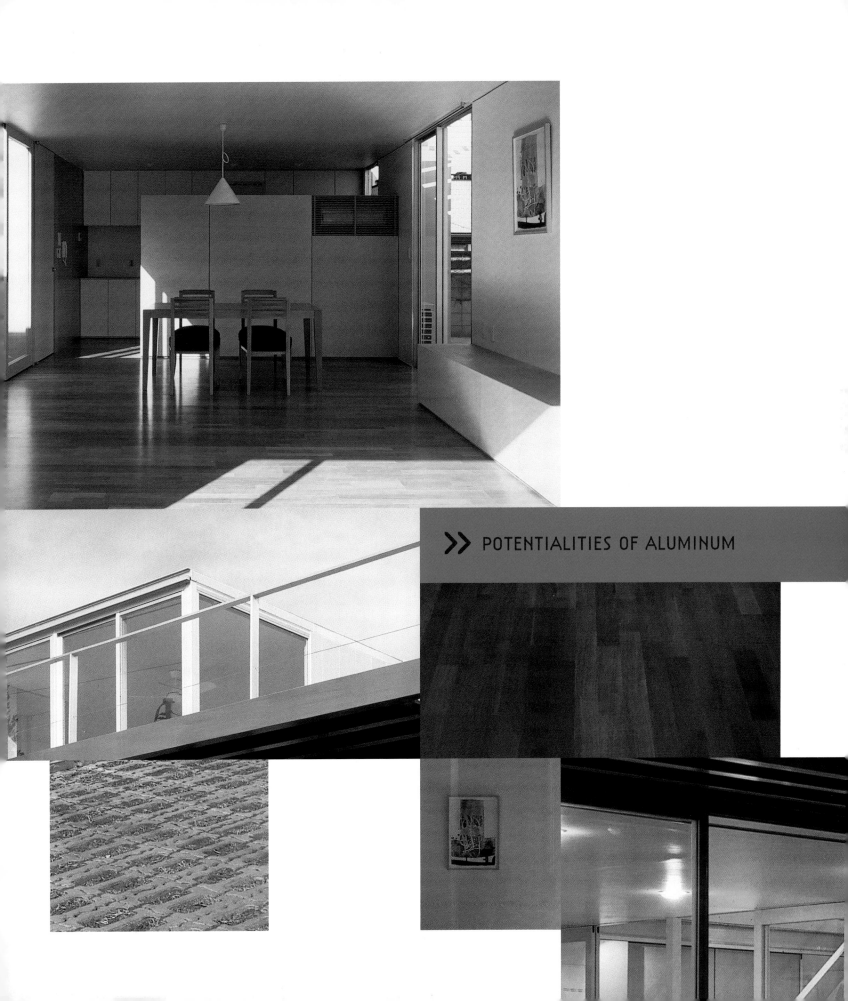

First Floor Plan

Elevations

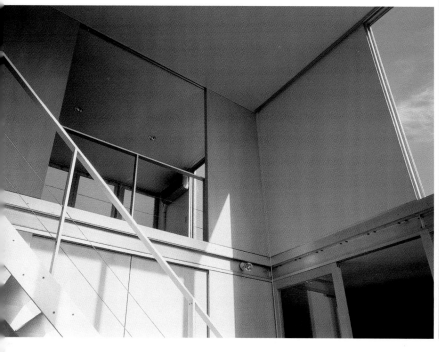

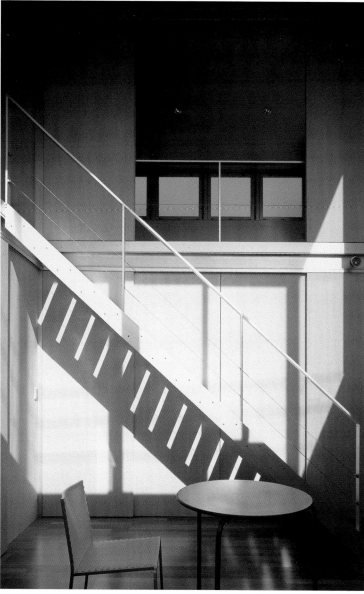

All structure was made out of aluminum, becoming the first aluminum house in the world. The architect´s intention was to realize a light and comfortable space for living.

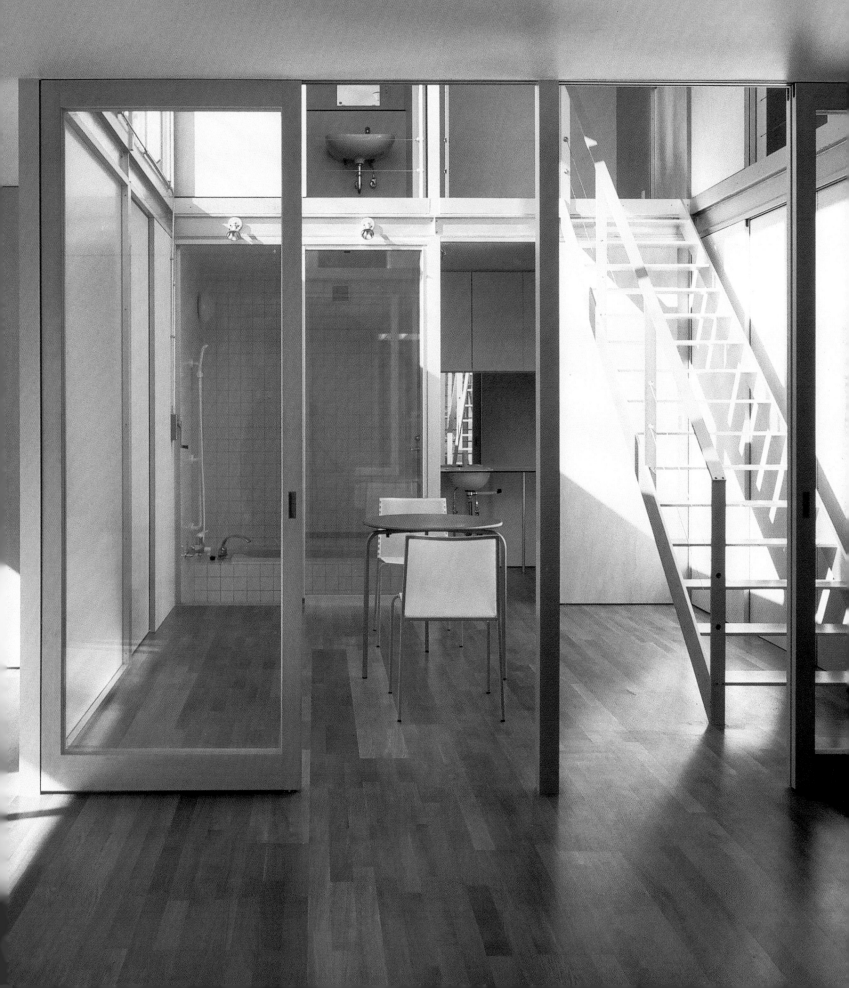

Second Floor Plan

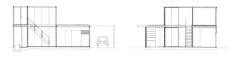

Elevations

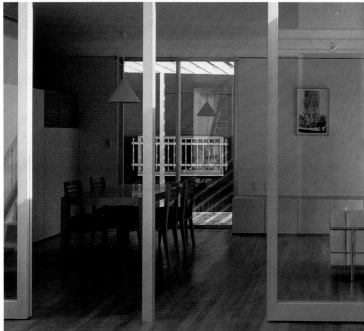

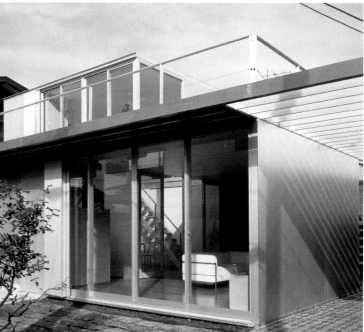

>> All common living space, including the bathroom and the kitchen, is situated in the first floor, while the guest room and the roof terrace are located in the second floor.

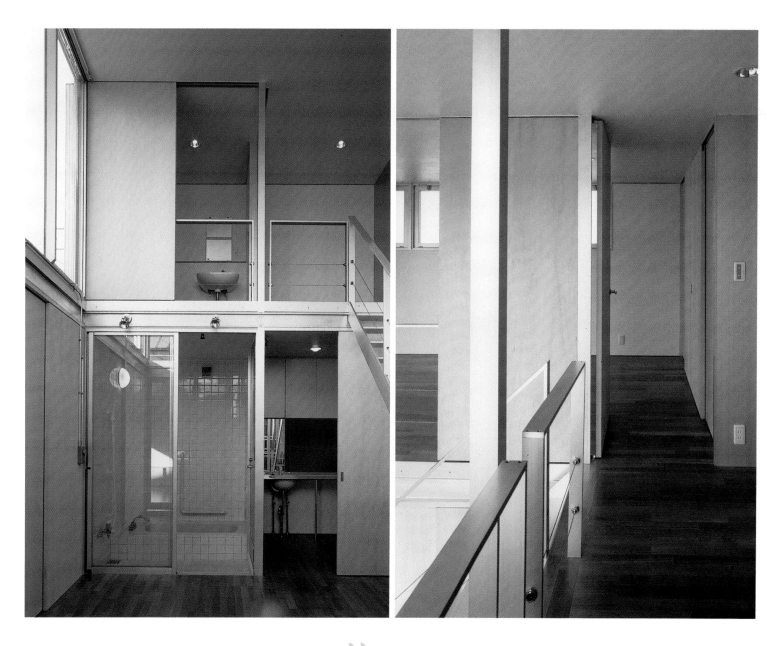

>> Thanks to the structure of aluminum, and the effect of the Patio-like sunroom, the inner space becomes bright, in a fluid connection just as if it were one single room.

Yutenji T House

Toyo Ito & Associates, Architects
e-mail: **mayumi@toyo-ito.co.jp**

Completion Date: **1999**
Location: **Tokyo, Japan**
Floor Space: **1595 ft²**

Photographer: **Shinkenchiku-sha**

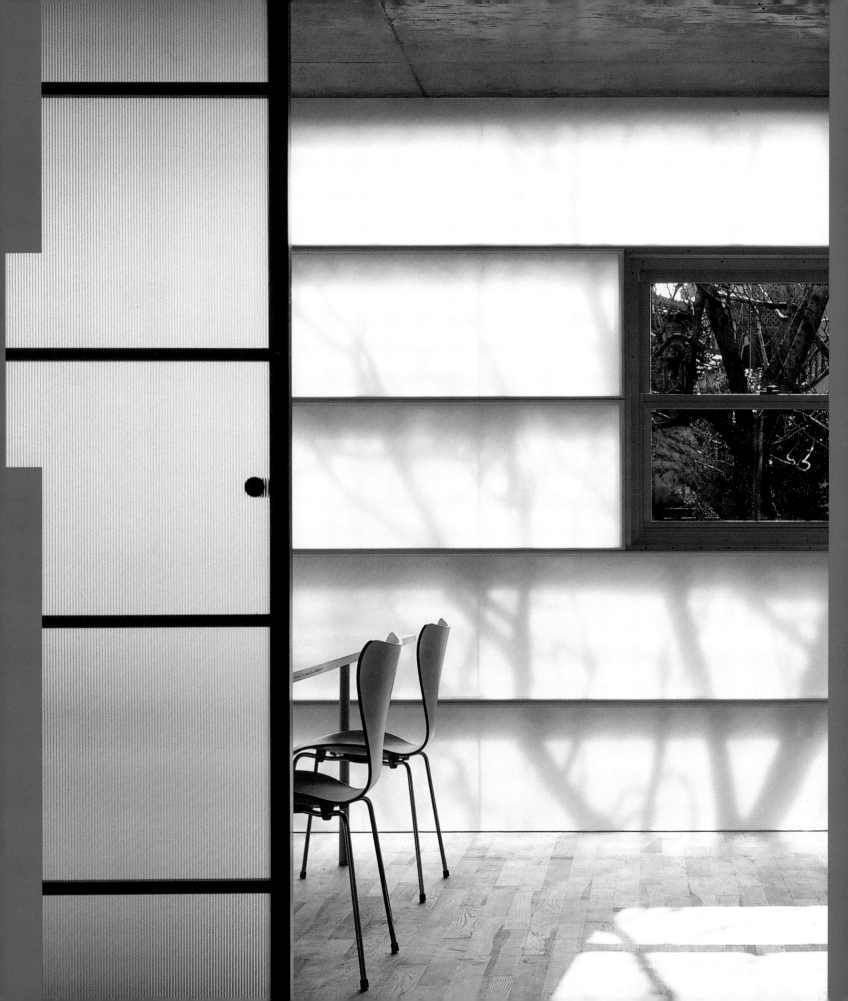

Since the mid 1970s, Toyo Ito has been one of the world's most innovative and influential architects, creating new concepts for life in modern cities, and searching for an architecture appropriate to our electronic, image-oriented consumer society. His works "Tower of Winds" (1996) and "Egg of Winds" (1991) are interactive landmarks whose designs seek to represent the invisible electronic world as a parallel to our physical environment. In 2002, the architect was awarded with Golden Lion at the Eighth International Architecture Exhibition of La Biennale di Venezia in recognition for his distinguished and valuable contribution to contemporary architecture.

At present, Toyo Ito is working on the ongoing project known as the "Fira de Barcelona/Barcelona Trade Fair" in Spain. He is also working on other projects, such as a housing Project in Groningen, Holland, and a concert hall in Matsumoto, Japan.

Yutenji T House is located on top of a hill in Tokyo's Setagaya district. The building, deeper than its appearance from its facade would suggest, faces a 26ft wide road full of heavy traffic on its eastern side. Two additional houses next to it, belonging to the same family, share a common garden. The owners of the house are a married couple, both graphic designers.

A graphic designer's day starts in front of a blank white paper, and once the workday is over, he or she "resets" and returns to that blank white paper all over again. With consideration of this craft, the architect felt that the owners needed a sorted space that acted like a stage of their own life and work styles. The upper floor of the house incorporates the living room and the couple's atelier. The boundary between the interior and exterior of the facade is covered by a double-pane, semi-transparent glass. As the distribution of natural light keeps on changing subtly, the very same space looks different according to the direction of the viewer. The architect tries here to amplify the human sense of sight in using the natural light in the room. Far from coordinating interiors in a regular way, Toyo Ito tries to extract the sense of how its inhabitants "feel" in the space. ≪

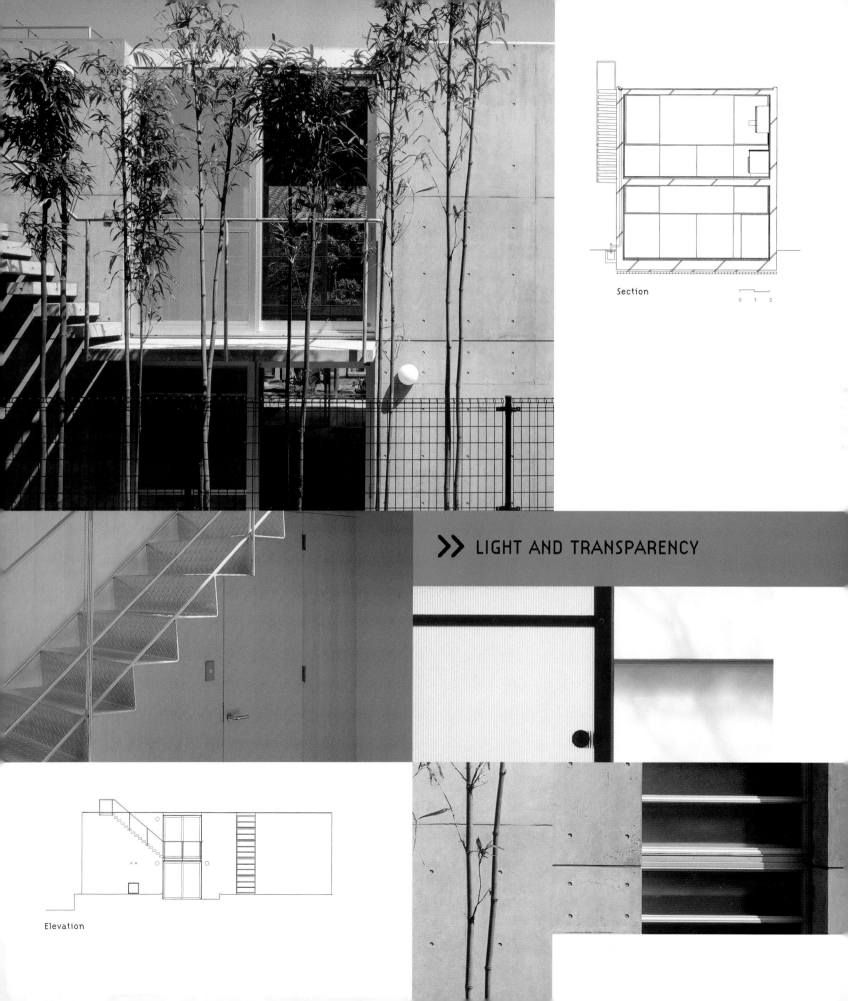

Section

0 1 2

>> LIGHT AND TRANSPARENCY

Elevation

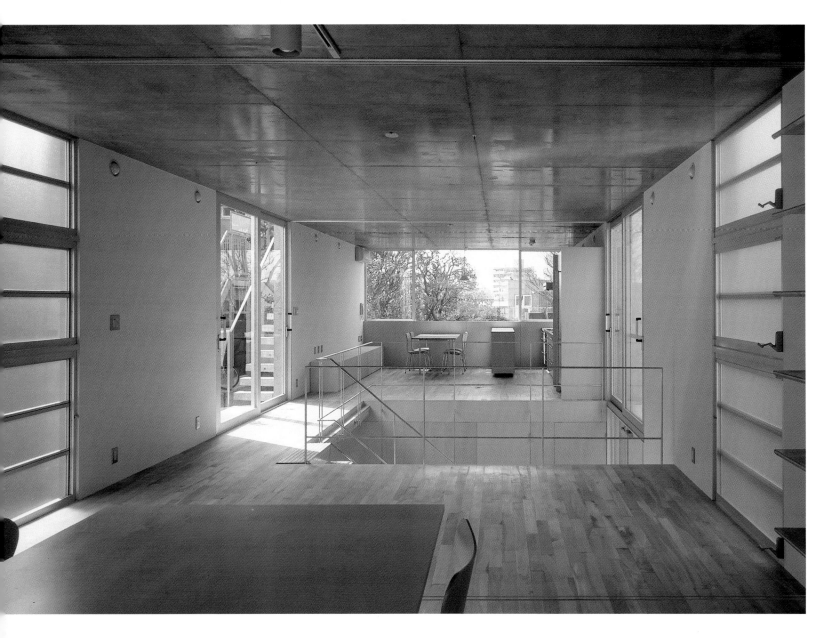

>> Despite being built with concrete, glass and wood, the space conveys a lot of airiness and lightness.

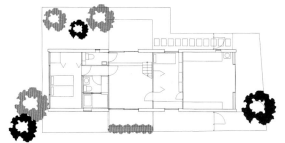

First Floor Plan

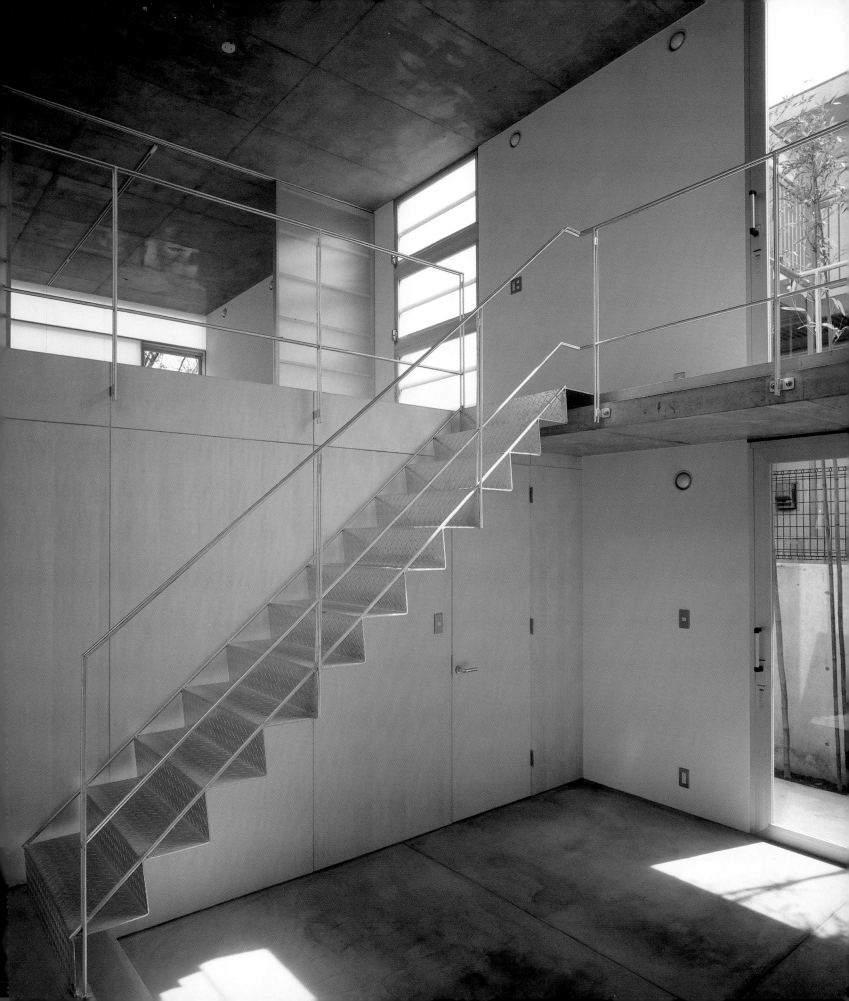

Tezuka Architects

Wall-less House

Takaharu and Yui Tezuka Architects + Masahiro Ikeda
e-mail: tez@sepia.ocn.ne.jp
url: www.tezuka-arch.com

Completion date: 2001
Location: Tokyo, Japan
Floor Space: 2581 ft²

Photographer: Katsuhisa Kida

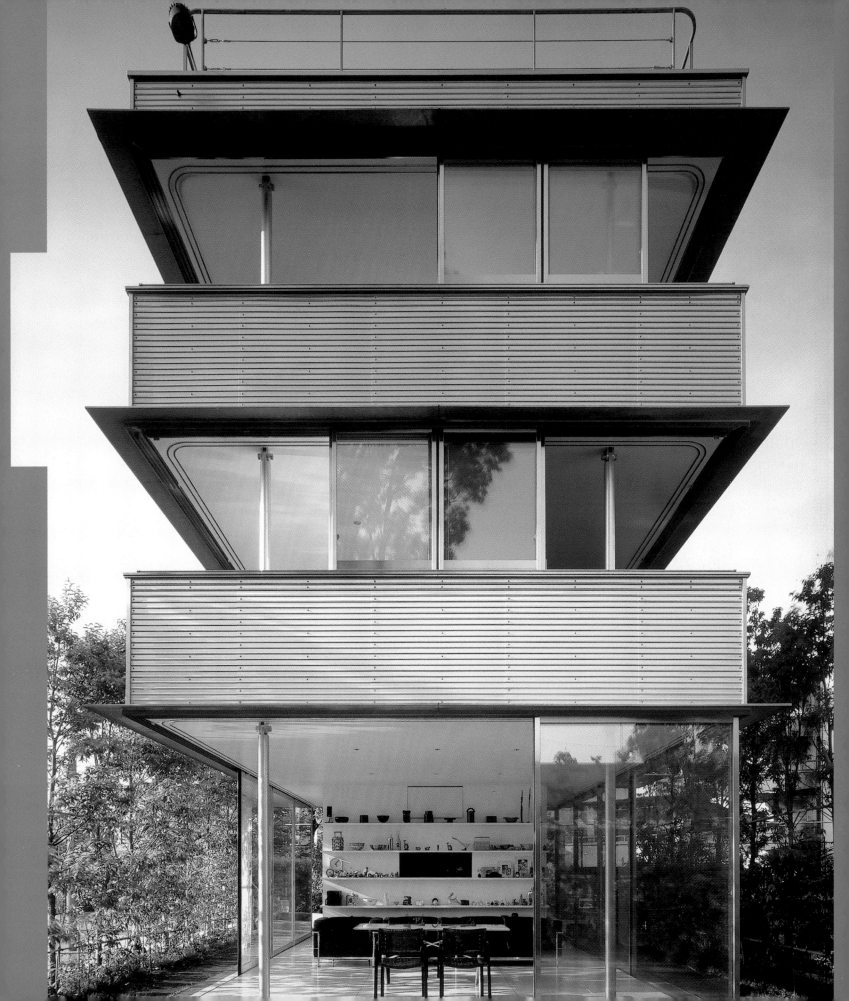

Takaharu (Tokyo, 1964) and his wife Yui (Kanagawa, 1969) Tezuka established their own architectural atelier in Tokyo in 1994. Previously, they had respectively worked in Richard Rogers' studio in London and studied under Professor Ron Herron at the University of London. Tezuka Architects have, at present, become one of the most emblematic young architectural Japanese studios. Among their most representative work are projects like "The Wood Deck House," which received an award from The Tokyo Society of Architects; "Kawagoe Music Apartment;" "Machiya House;" "Megaphone House;" "House to catch the Sky;" and "Roof House," which was awarded the Yoshioka prize and the 2002 Japan Institute of Architects price.

Tezuka's main motto is to try to turn their client's most bizarre and whimsical dreams into reality. That explains the wide variety and range of their works. Depending on the type of site of the project and the needs of their particular client, each building adopts a very specific and marked character.

As for the Wall-less House, the large site is in a dense residential neighborhood of Tokyo's Setagaya district. The building is located in an area that provides a rare opportunity, according to the architects, to open the house completely to the surrounding landscape, an environment reminiscent of a retreat villa in the countryside. Occupying only 20% of the site, the dwelling leaves ample space around it for a truly open, continuous space, or a "truly wallless house." Using a lightweight steel and a load-bearing frame structure, the axial loads are distributed through only a utility core in the center and two thin columns, therefore opening the living space to the outside completely on all sides. The floors, thus, float in the air, surrounded by trees that help provide for greenery as well as privacy. «

>> FEEL LIKE FLOATING IN THE AIR

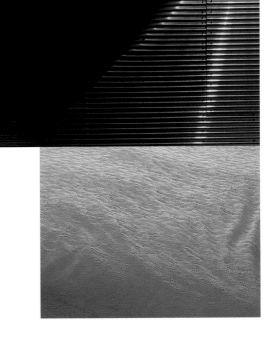

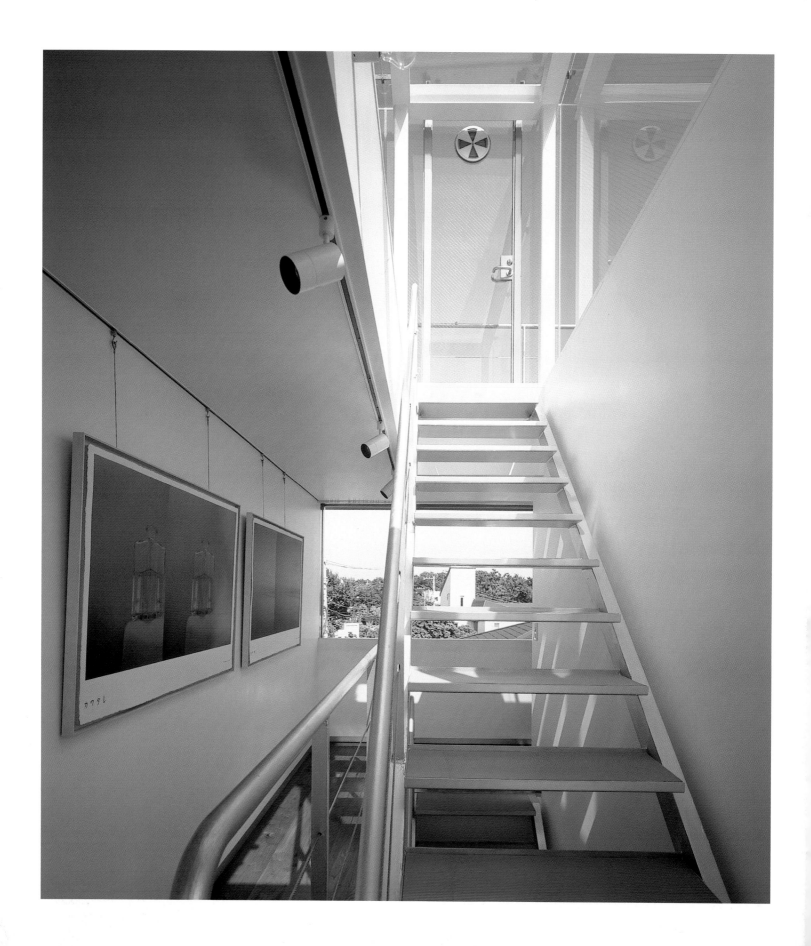

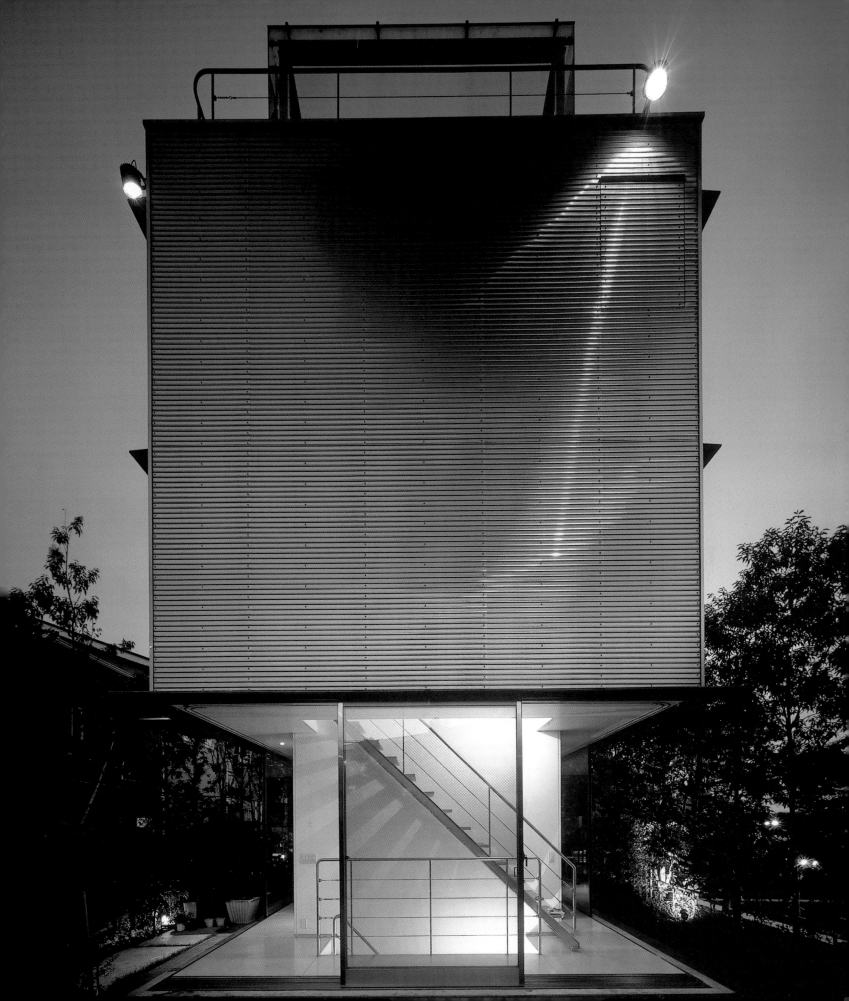

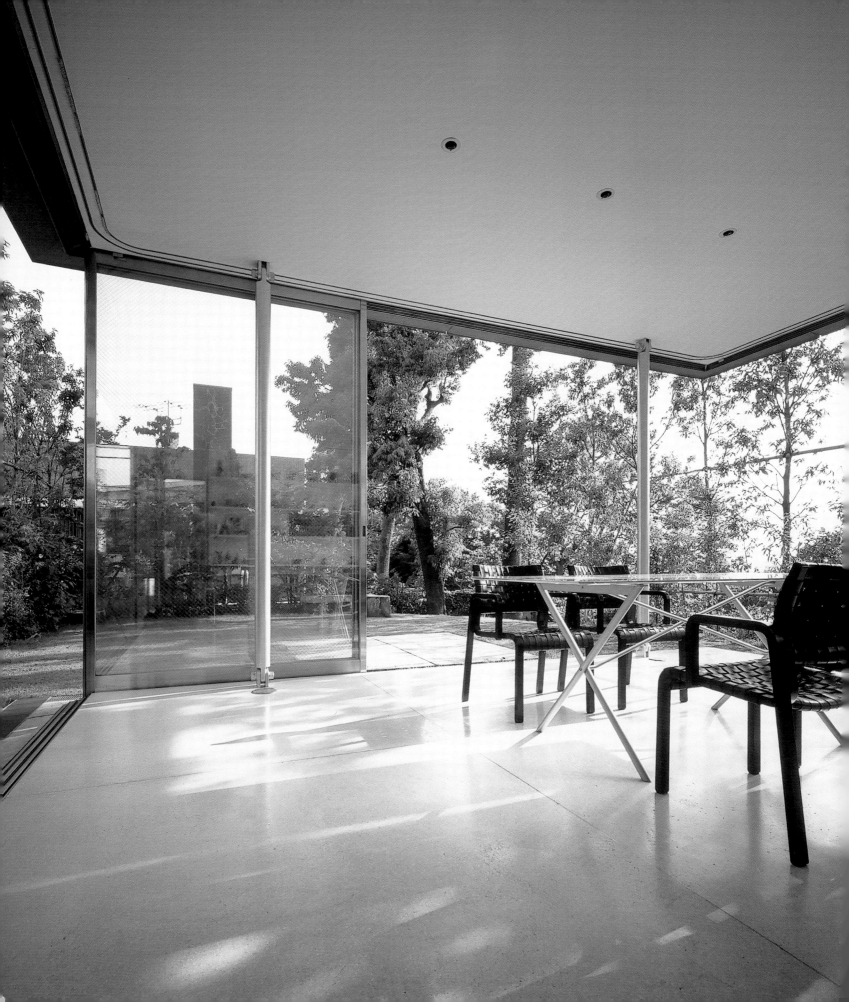

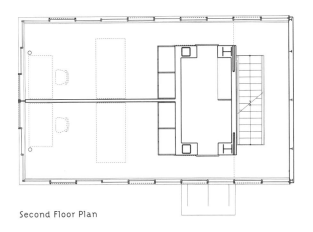

Second Floor Plan

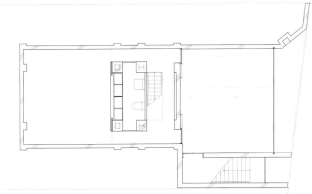

First Floor Plan

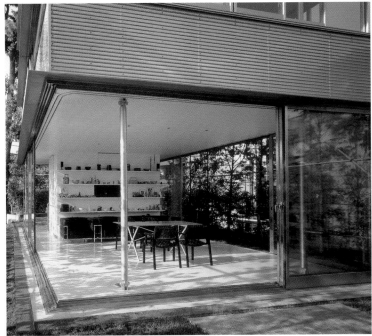

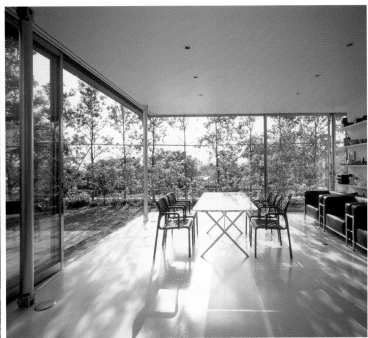

>>

The house is supported only by a central core and a pair of extremely thin columns. Thus, there is no wall on the ground floor level and the internal space extends 360 degrees out on to the garden.

Third Floor Plan

0 1 2

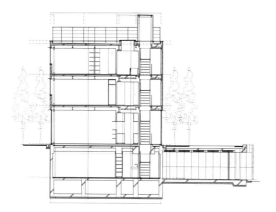

Section

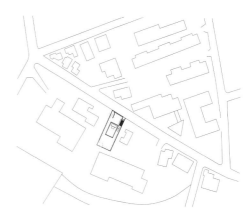

Site Plan

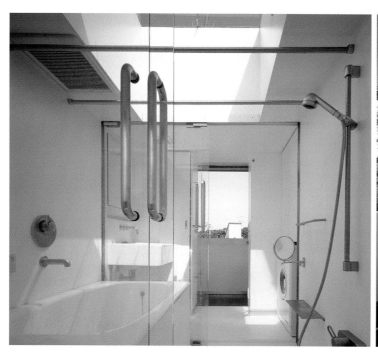

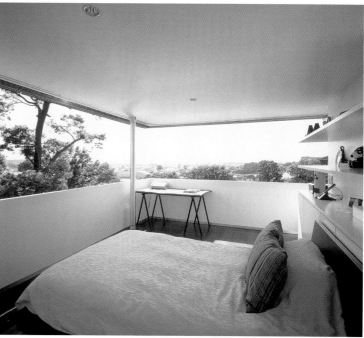

Thanks to an effective top light, the bathroom becomes a cozy and a cheerful space. Despite being in central Tokyo, the inhabitants can feel nature and the change of seasons all the time.

Right: View of Tokyo from the terrace.

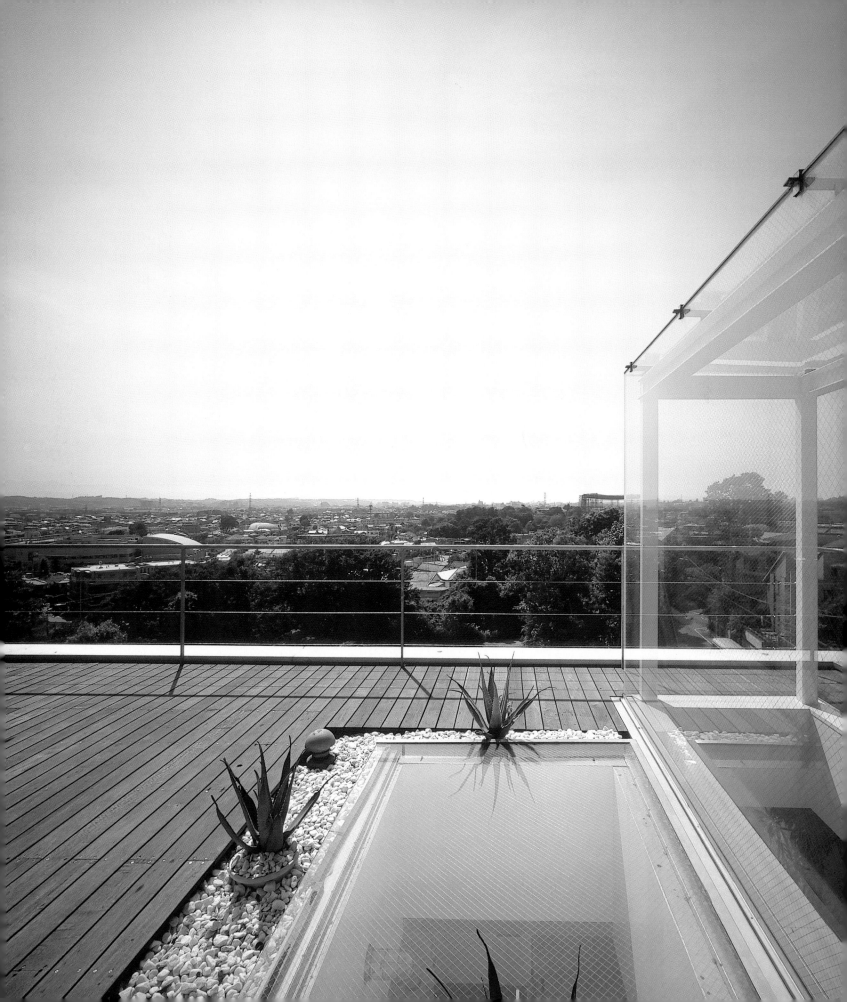

milligram studio

Kamakura

milligram studio / Tomoyuki Utsumi
e-mail: info@milligram.ne.jp
url: www.milligram.ne.jp

Completion Date: **2002**
Location: **Kamakura, Japan**
Floor Space: **926 ft²**

Photographer: **Takeshi Taira**

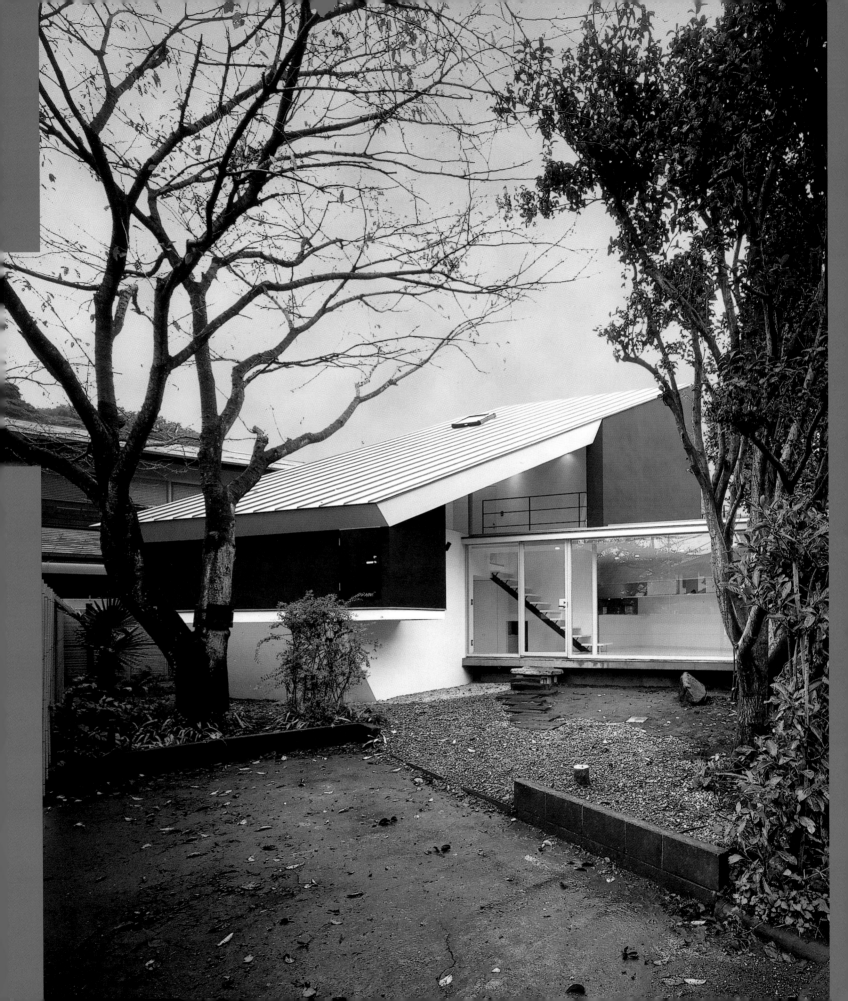

Tomoyuki Utsumi (Mito, Japan, 1963) is a graduate from The Royal College of Art in London, England and Tsukuba University in Japan. After setting up his own studio in 1988, he soon became one of the most prominent emerging architects based in Tokyo.

The location of the "Kamakura" house lies along the path leading to the mountain promenade of Kamakura. The old Buddhist temple, "Jokumyohji", is located north of the site. The site used to be the front garden of the neighbor's house. Several trees, such a maidenhair tree and a tall cherry tree, are still planted there. Since the site is located in a designated conservation area of the historical city of Kamakura, the house location was established according to the position of these existing trees. People living in Kamakura believe that conservation creates history. The young owner of the house, a native of the city of Kamakura, decided to preserve the city's history by allowing the trees to remain in the area.

For the construction of this tiny house, neither special methods nor any novel materials were used. Because of the client's special request, the house presents a unique form, with the pitch of the main roof designed so as not to disturb the symbolic cherry tree.

A flat, one-story level inserted under the roof, with a front garden, places the site at a plane level with the surrounding cityscape. The main ground floor floats slightly off the ground, while an upper floor and a lower floor are accommodated under a sloped roof. In order to make this three-dimensional space composition more attractive, several loopholes that connect different levels are created, so that it becomes possible to wander all around the house. Every corner is given a characteristic mark. They are interconnected with each other at a crossing point of two axes. As a result, this compact house gives the impression of being more spacious than its actual floor area. With the small balcony devised on the rooftop, the owner can enjoy picturesque views of the temple under the moonlight with the mountains in the background. «

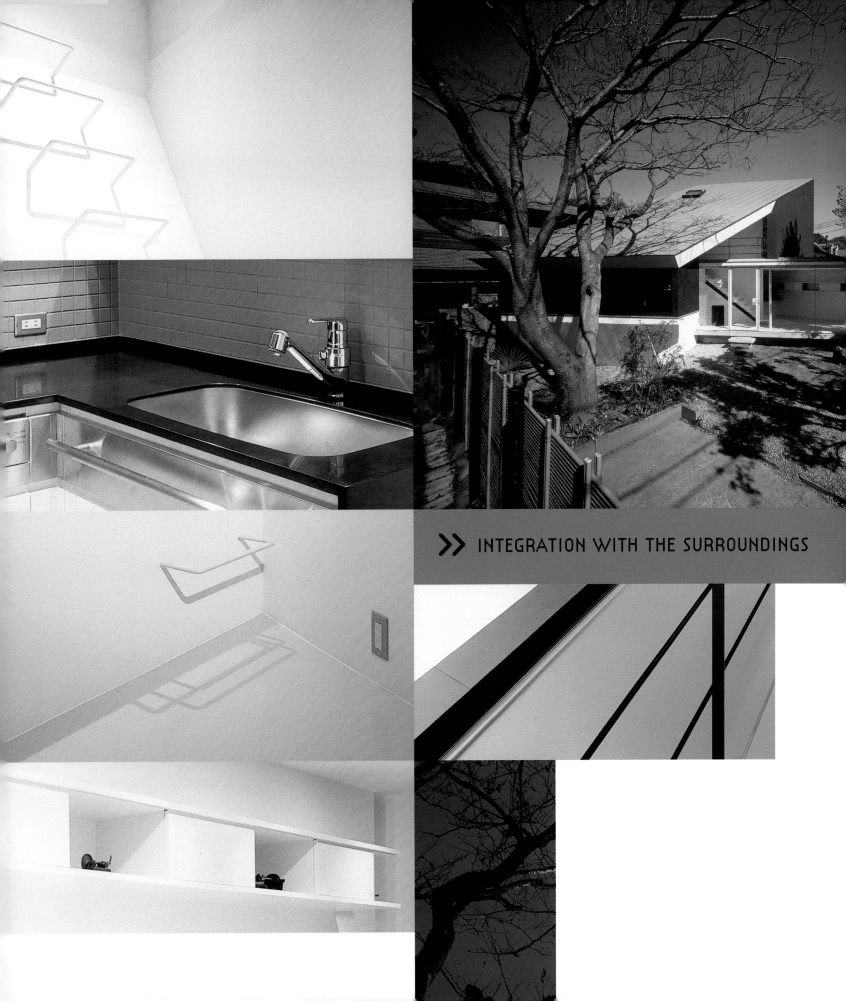

>> INTEGRATION WITH THE SURROUNDINGS

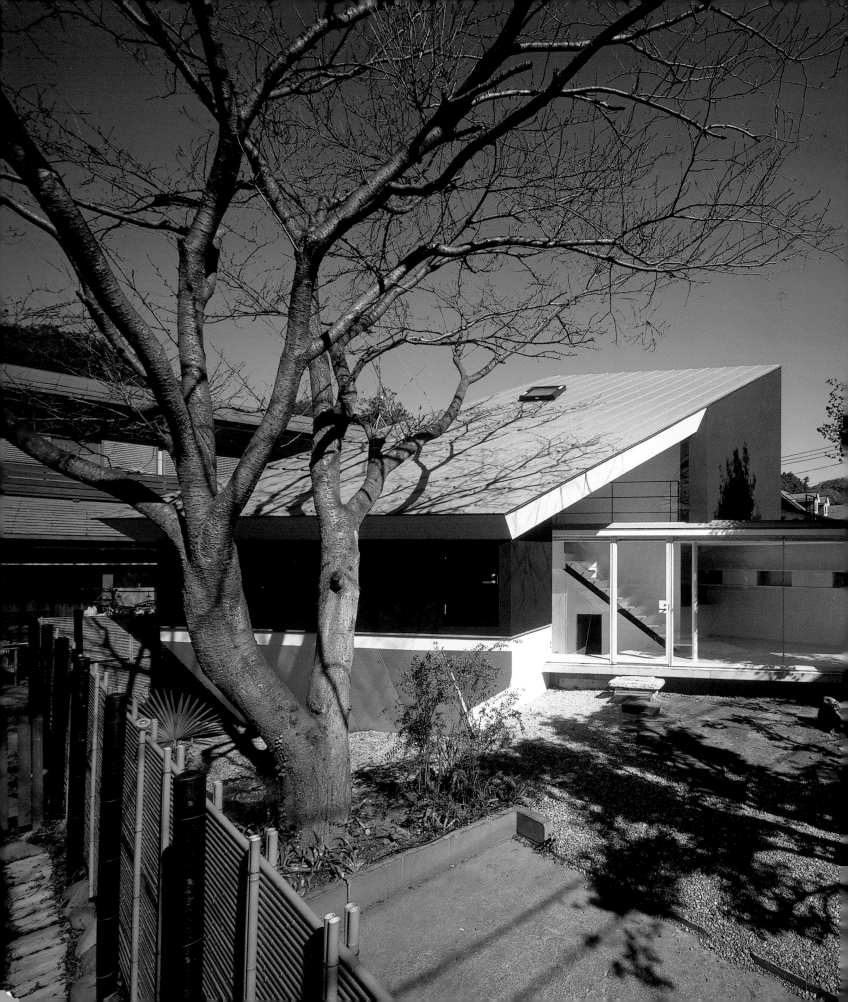

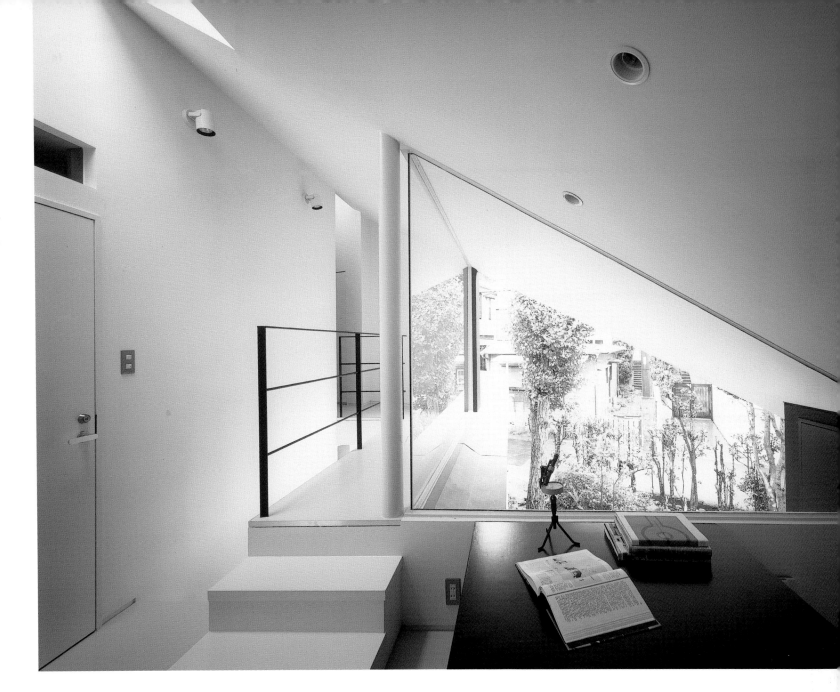

 View of the façade and the garden. The site is located in a designated conservation area of the historical city Kamakura, thus the house was designed to be integrated to the surroundings.

Above: View of the study room characterized by its triangular roof .

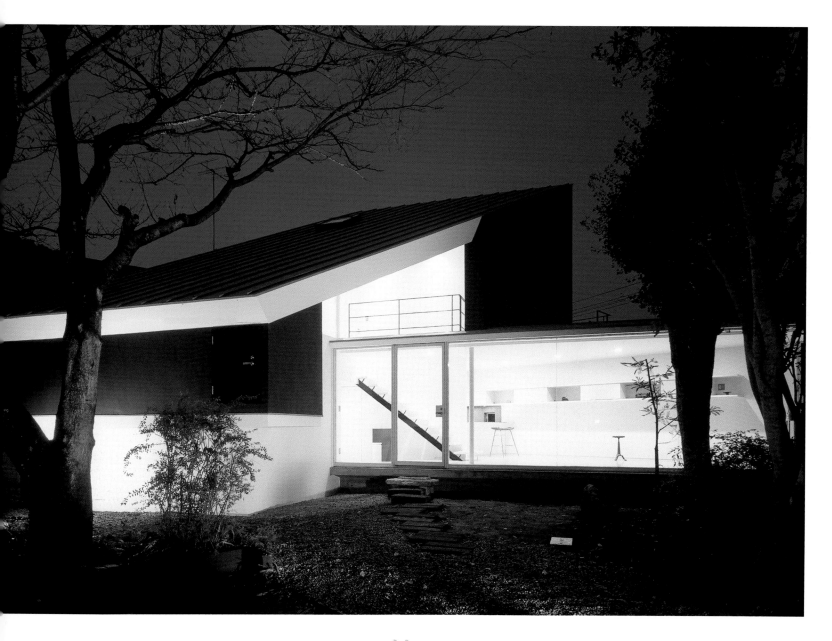

>> Night view of the house. The main roof was designed not to disturb the symbolic cherry trees. The owner can enjoy picturesque views under the moonlight from the small balcony on the rooftop.

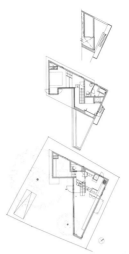
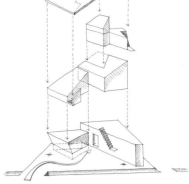

Plans and Axonometric

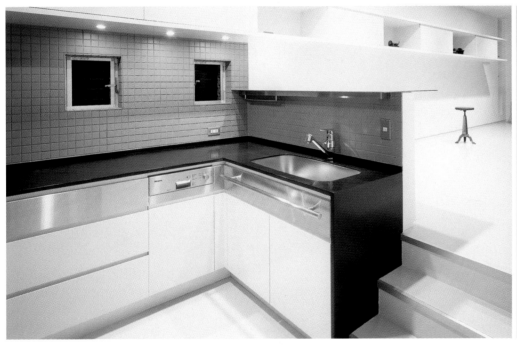
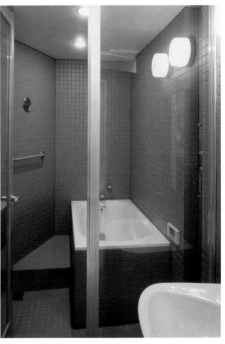

>> The kitchen and the bathroom were designed functionally with a fresh color scheme. Through the plans, you can see the unique form and construction system of the house.

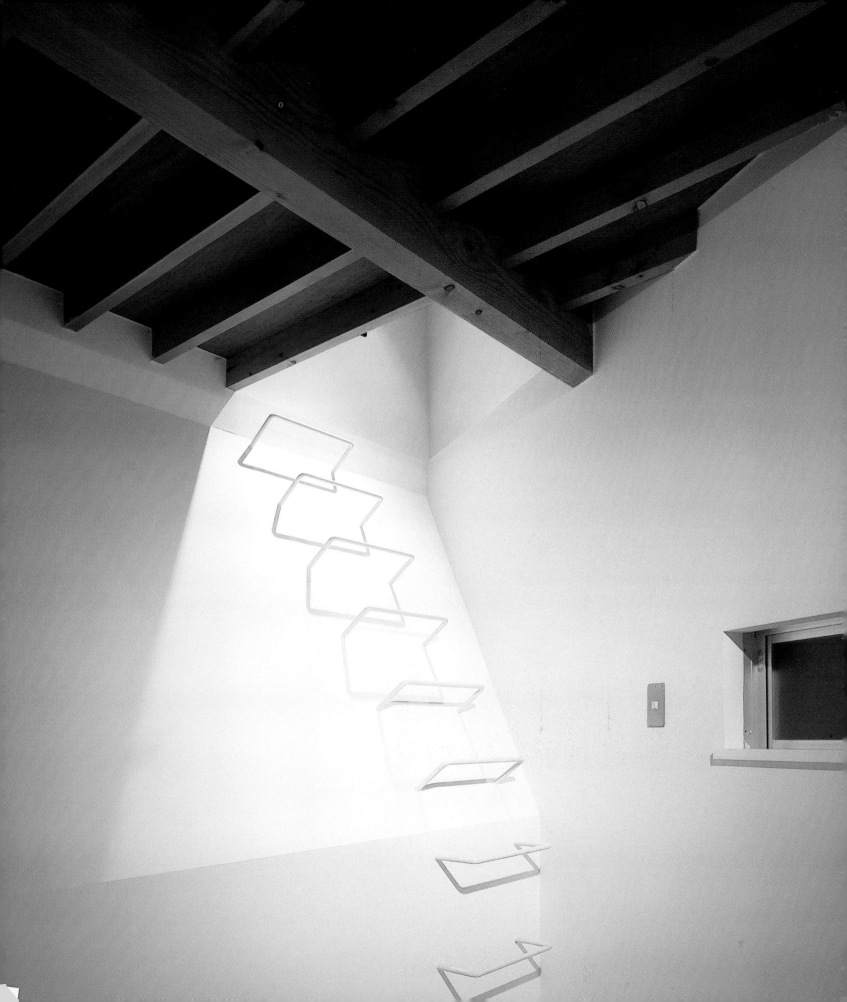

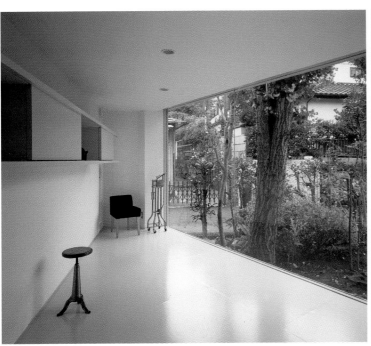

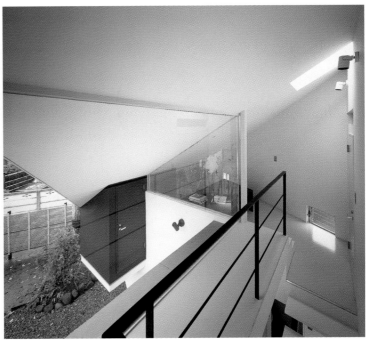

The house is commonly called "a tag house", because there is a passage all around it so that children may play inside. Thanks to this passage, the inner space of the house looks larger than its actual size.

milligram studio

House in
Senzoku

milligram studio / Tomoyuki Utsumi
e-mail: info@milligram.ne.jp
url: www.milligram.ne.jp

Completion date: **2002**
Location: **Tokyo, Japan**
Floor Space **1213.41 ft²**

Photographers: **Takeshi Taira / Satoshi Asakawa**

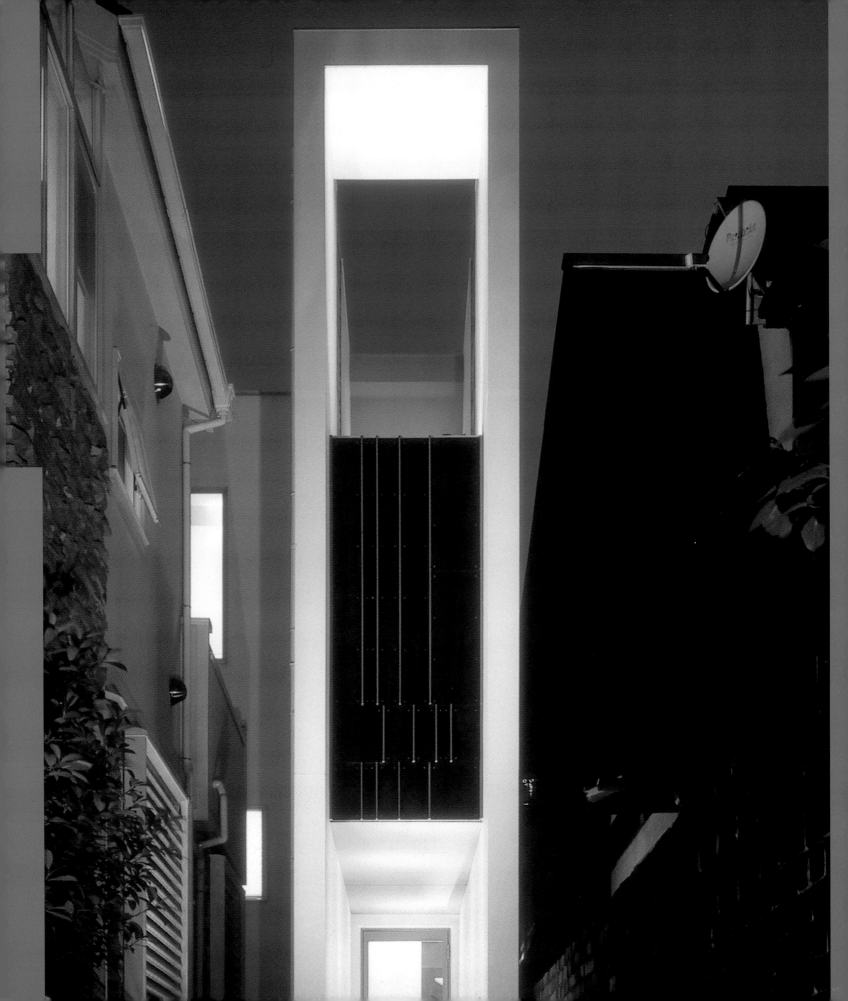

The site of the House in Senzoku is located in a quiet residential area in the center of Tokyo. Boasting plenty of tall, preserved ancient trees and a large front garden, the old house in its surroundings shows the vestiges of what used to be an area teeming with individual houses, each of them located in plots of about 4304 ft² each. Nowadays, low-rise apartments and a heterogeneous mix of buildings lie in these former larger plots, which in time have been divided and subdivided into ever smaller pieces of land, thus forming a present-day Tokyo urban landscape.

The site of The House in Senzoku reminds us of a flag shape. The alley of the house (the flagpole), with a 7 ft wide access to the road, is 66 ft from the road itself to the main area of the building. This main rectangular space can be reached after passing through the long and slender tunnel that forms the alley. Though the architects have made the most of it, the area has very little marginal space left. The slight difference in height, between the house and its neighboring building, acts as a psychological and optical boundary between them. The spectacular and rational shape of the entrance of this dwelling provides a new elevation to its surroundings.

Natural light comes into the living premises only from the highest area of its southern section. Contrary to its first impression from the exterior, the structure of the building has a complicated composition, with five different levels forming the whole living area. The main bedroom is located in the semi-basement so as to secure privacy for its owners. In the upper level, from the kitchen area, its dwellers can look down to the lower level where the living room is situated. Despite the limited space, stairs have been wisely positioned connecting all levels with the exterior. The architects devised the simplest method of partitioning spaces, by means of two long theatre-like curtains. The divisions are aided by a high-tech heat insulation and air-conditioning system that accommodates to the diverse and occasionally extreme seasonal weather conditions in Japan. ≪

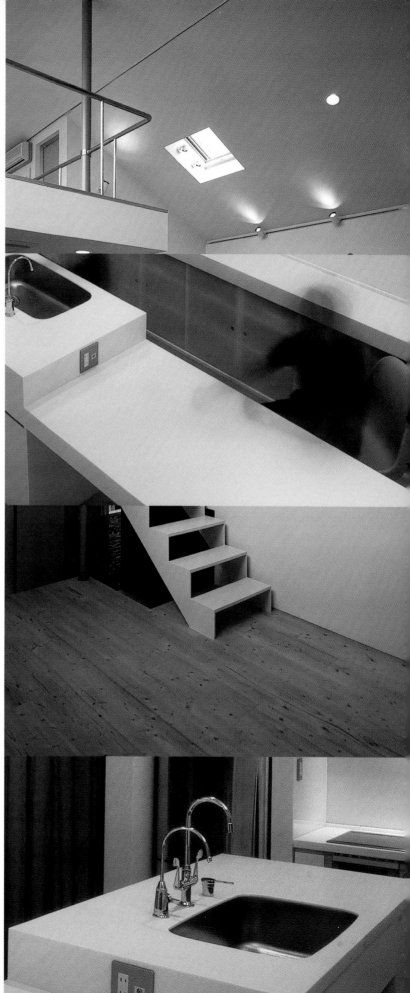

>> THEATRICAL EFFECT OF CURTAINS

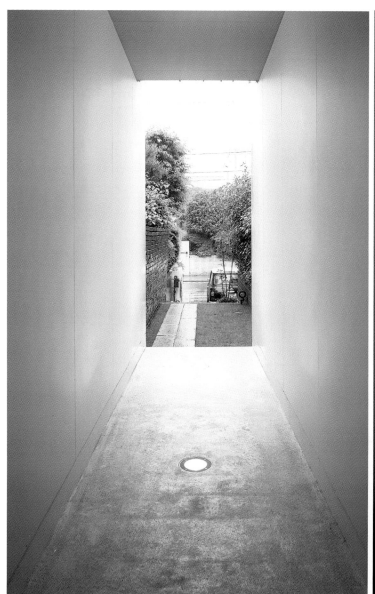

The impressive approach to the house was realized by taking advantage of the unique flag shape of this site.

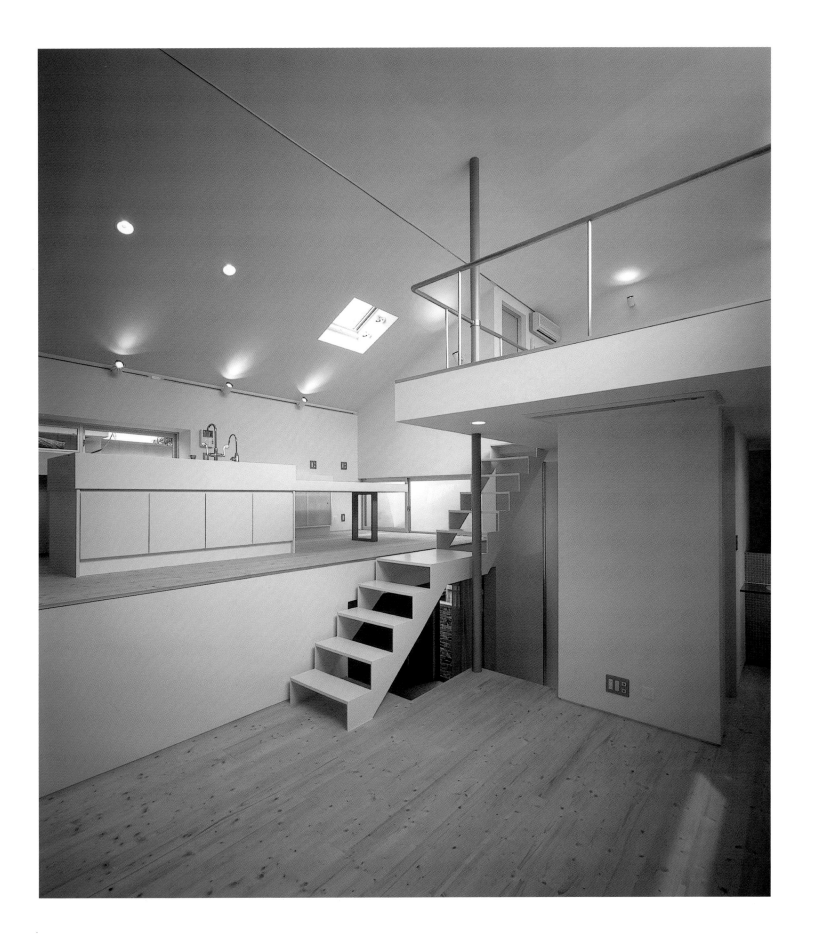

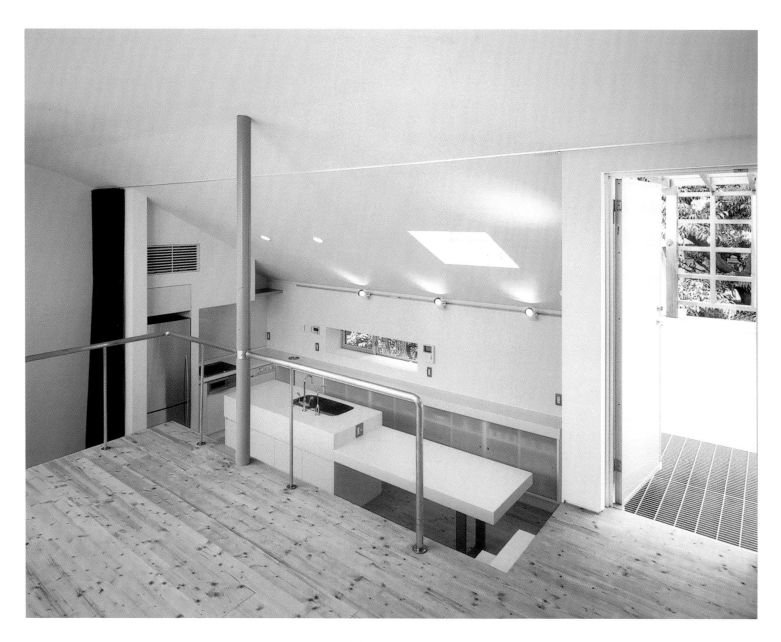

>> View of the kitchen, playing the leading role of the house.

inside mnm

48

First Floor Plan

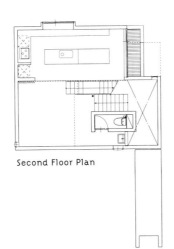

Second Floor Plan

0 1 2

Site Plan

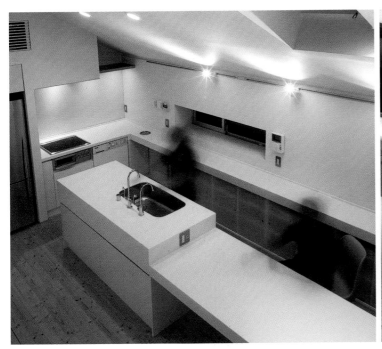

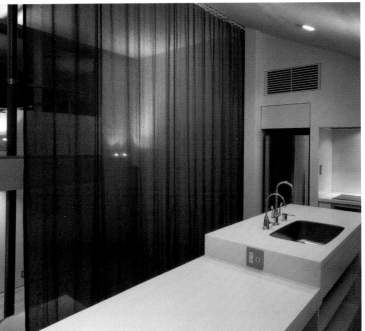

House in
Senzoku

49

Schär-Valkanover House

Blum & Grossenbacher
e-mail: **office@schaerholzbau.ch**
url: **www.schaerholzbau.ch**

Completion date: **1998**
Location: **Grossdietwil, Switzerland**
Floor Space: **2259.60 ft²**

Photographers: **Francesca Giovanelli and W. Schaer Holzbau, AG**

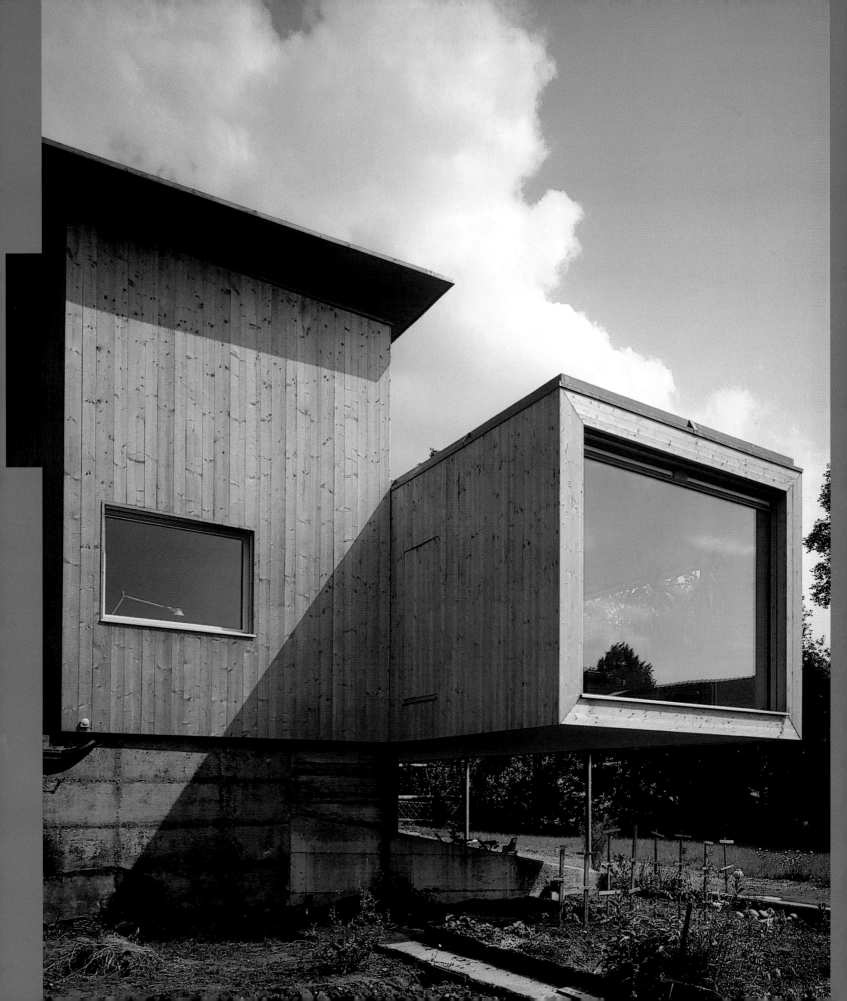

The Schär-Valkanover House, located in a residential and business area of Grossdietwil, Switzerland, directly bordering an agricultural zone, was completed in 1998. Next door, Walter Schär, who is quoted from vom Baum zum Raum, directs a modern carpenter's workshop that has belonged to the Schär-Valkanover family for four generations.

On the Fischbach, in an idyllic little valley where a mill, and later a sawmill once stood, more than a dozen wooden buildings per year are prefabricated today with a technique that allows them to be put on site within a few hours. Aside from this, the business continues on with the craft of classical carpentry.

Collaboration between Walter Schär, contractor and owner of the house, and the architectural office of Blum & Grossenbacher, has already been going on for several years. Their first jointly planned and executed wooden buildings date back to the mid-1990s.

Regarding the Schär-Valkanover House, the points of departure for the project were the need for individual space for the five members of the family, their decision to live in the immediate vicinity of their workplace, and the fact that there happened to be a remaining empty plot of land owned by the family close to the workshop.

The building's external appearance is one of two long volumes pushed together and running parallel to the valley dominated by the small river. With three levels altogether, the north volume is of greater height and it houses the compartmentalized structure of the bedrooms and facilities. Attached to this volume, on the southern part, a one-story bay rests on thin columns, providing an ample, open space as the main living room of the house. The entrance hall, a tiny domestic workshop, and the boiler room are located on the ground floor. The main level incorporates the kitchen, the office, and two bathrooms running parallel to the large living and dining room. According to Walter Schär, the house in all of its simplicity is less of a house than a multifunctional object of use. It is the result of an excellent and practical combination of prefabrication techniques and handcrafted finishing. **«**

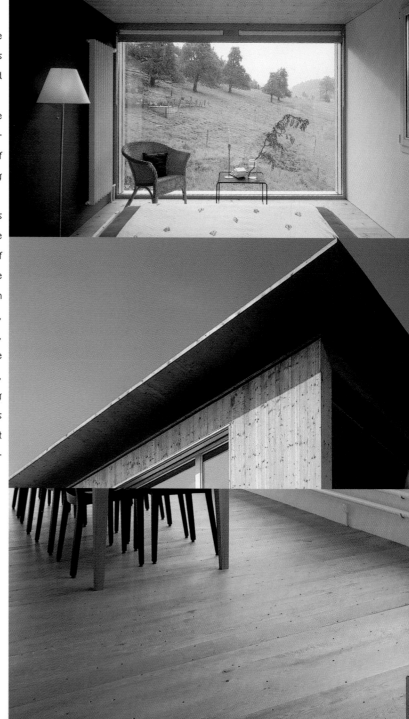

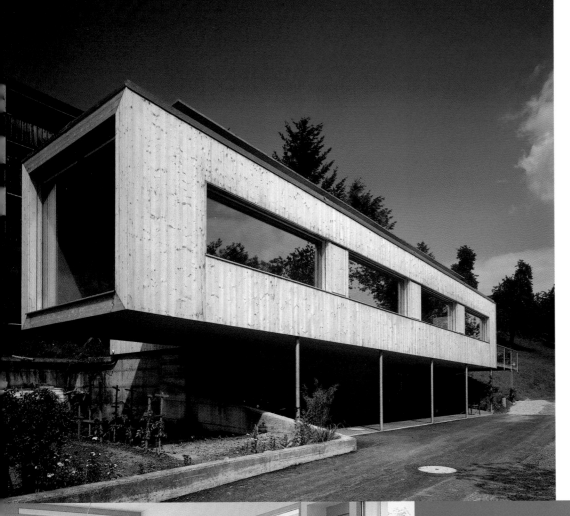

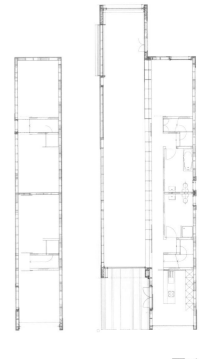

Third Floor Plan Second Floor Plan

>> VERSATILITY OF WOOD AS MATERIAL

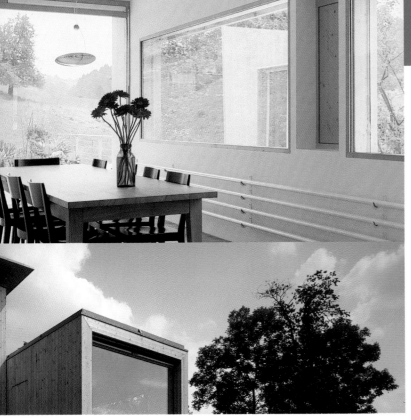

Axonometric

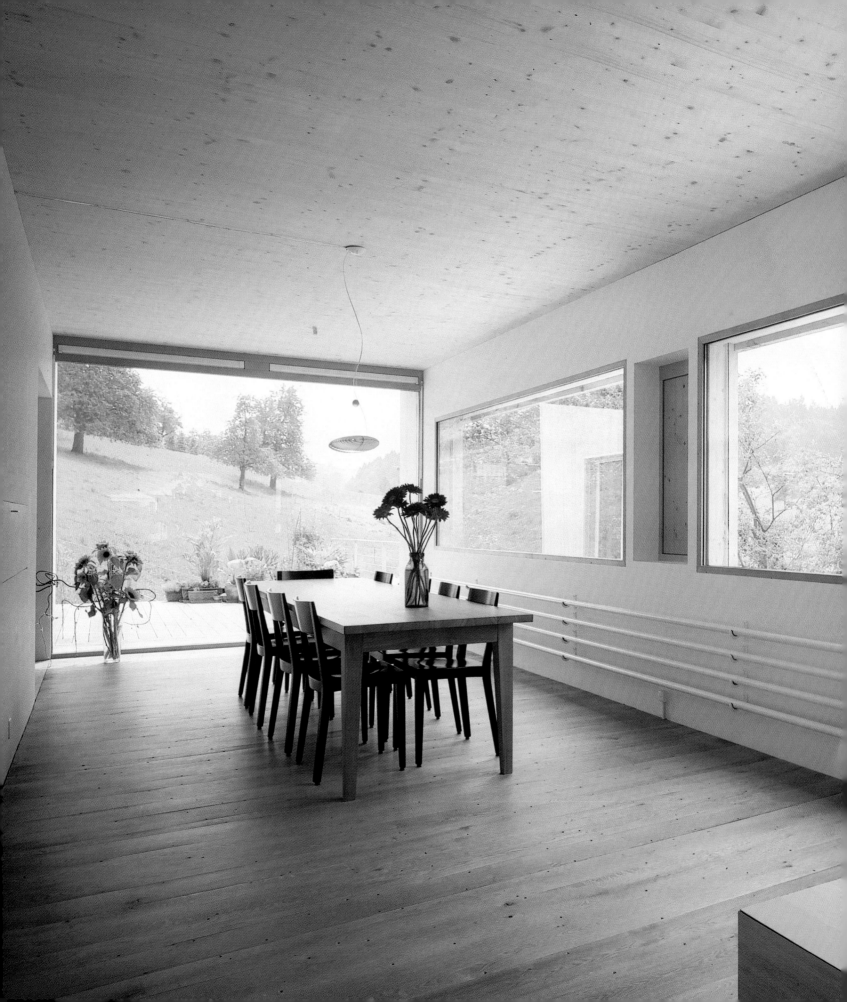

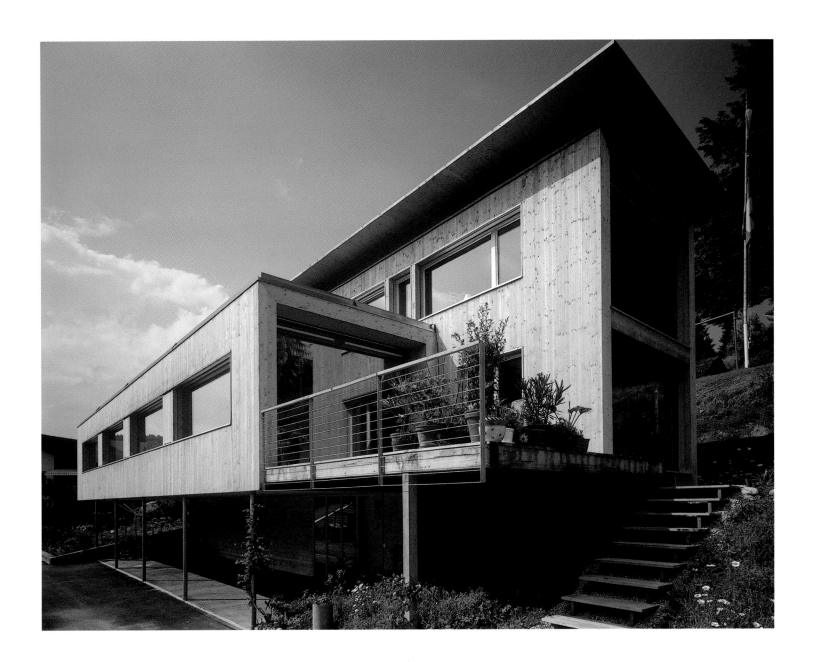

Sections

Elevations

Schär-
Valkanover
House

55

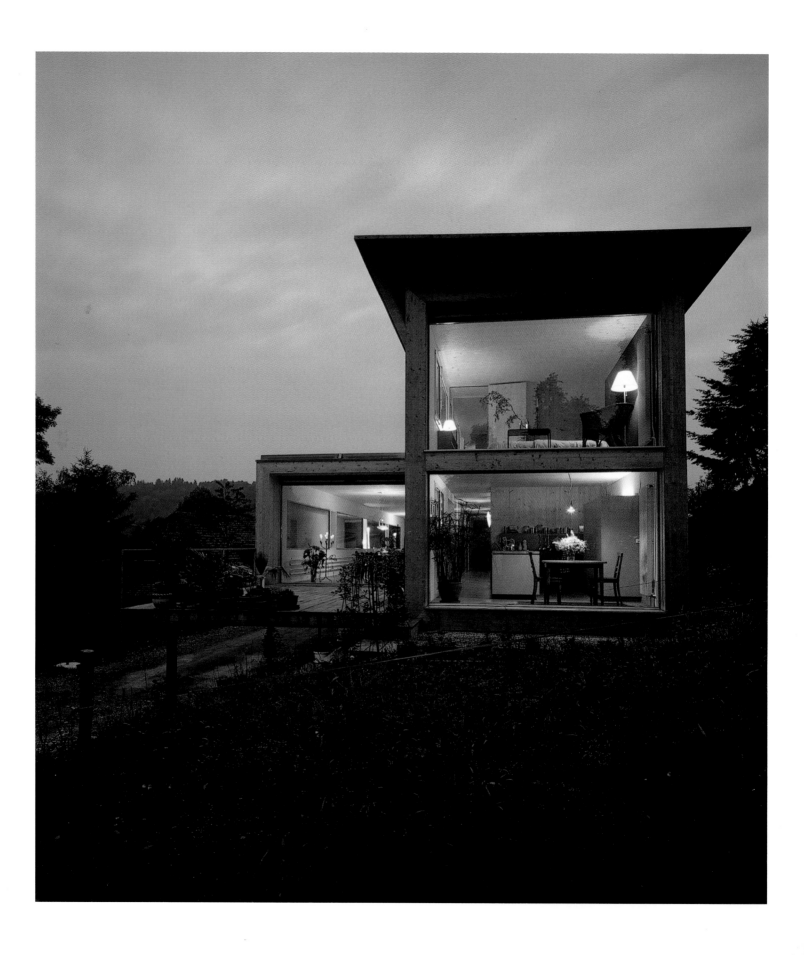

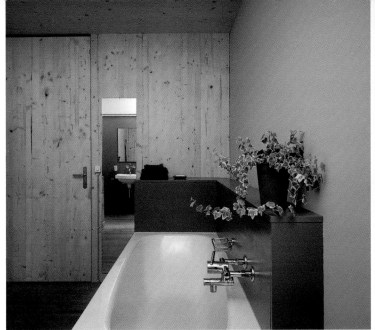

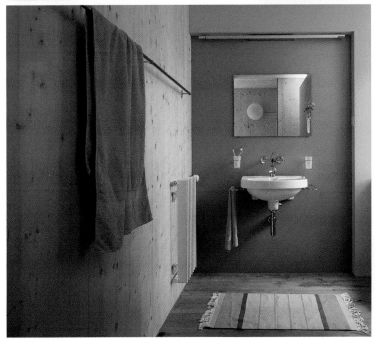

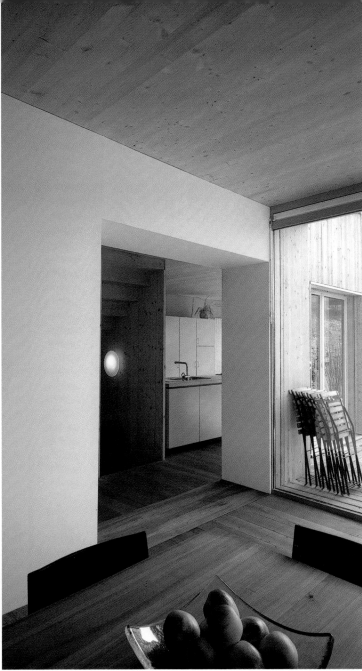

Left: Night view of the house. Integration of its modern façade to the countryside.

Details of the inner space. Its handcraft finish give the house added warmth and originality of character.

Ai Wei Wei's House

Ai Wei Wei
e-mail: aixx@sohu.com
url: www.archivesandwarehouse.com

Completion date: **1999**
Location: **Beijing, China**
Floor space: **5380 ft²**

Photographer: **Ma Xiaochun**

Ai Wei Wei was born in Beijing in 1957. Following his studies at the Beijing Film Institute in the late seventies, he moved to New York where he entered the Parsons School of Design and Art Student's League. After living in New York for thirteen years, he returned to his home city, Beijing, where he now resides.

In Beijing, Ai Wei Wei works as an artist, architect, landscape designer, and interior designer. Through his landscape design, he has recently completed the site of "The Commune" by The Great Wall Project. As a conceptual artist, his works have been shown in China and in the United States. Ai Wei Wei is also the author of well-known books such as The Black Cover Book (1994), The Grey Cover Book (1995), and The White Cover Book (1997). These publications are characterized for having made a considerable contribution to the awareness of contemporary art and a much needed platform for conceptual artists in China.

At present Ai Wei Wei continues to explore contemporary artistic values and conceptual issues in his workshop studio in South Beijing. Some of his projects include blue and white porcelain-based works, traditional furniture-based work, as well as photographic work based on "The Lunar Festival" and its Eclipse in 1997.

The Ai Wei Wei's house project, designed by the artist himself, comprising both his own studio and private dwelling, has a total floor area of 5380 ft^2. It consists of a reinforced concrete skeleton-frame structure – left exposed internally – with reddish brick infill panels. An out-skin of grey facing bricks is drawn over the structure and articulated with carefully proportioned window openings. The principal element of the scheme is the two-story studio space set at right angles to the living tract. The windowless studio receives daylight solely from two skylight strips above. The number of materials used was reduced to a minimum. Ai Wei Wei contends that, when designing his own studio, he took special care of the scale, proportion, and the proper usage of the basic materials, since these, he believes, are the most important elements of architecture. **《**

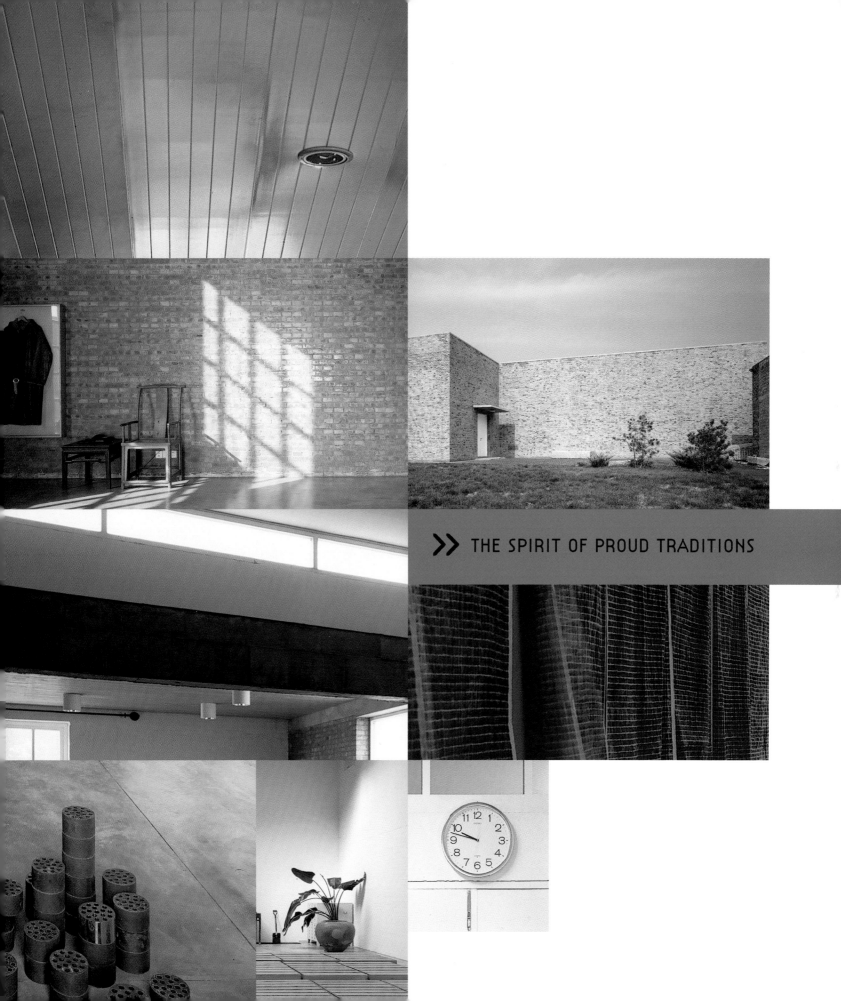

>> THE SPIRIT OF PROUD TRADITIONS

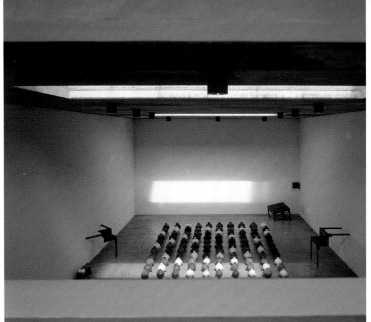
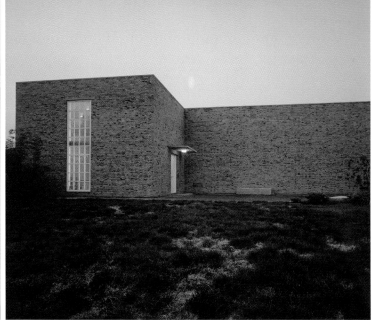
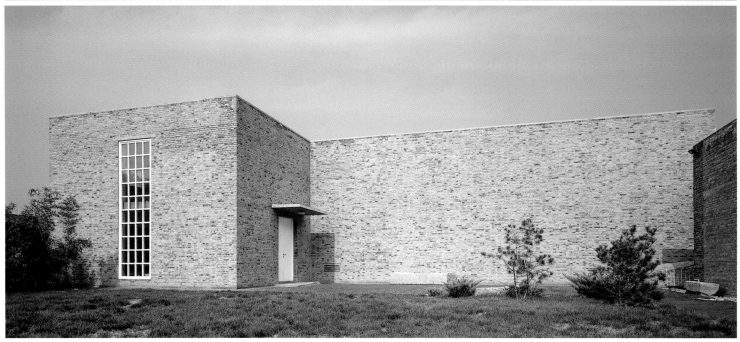

>> The house was built with local materials.

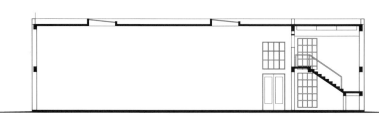

Section

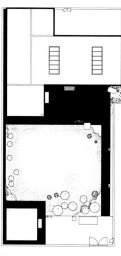

First Floor Plan

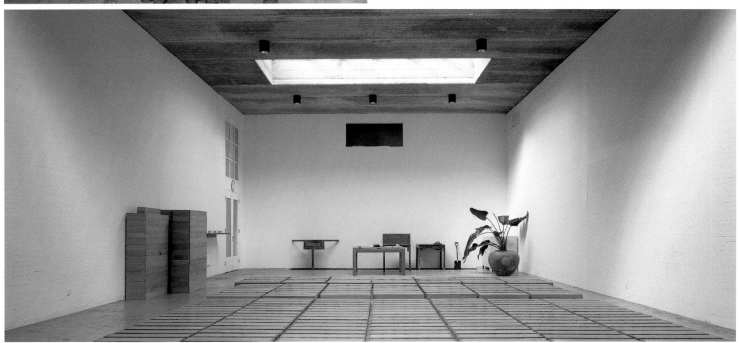

>> The studio was designed to absorb effectively plenty of natural light from the ceiling.

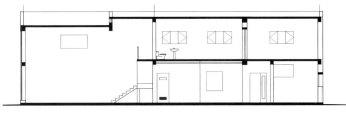

Section

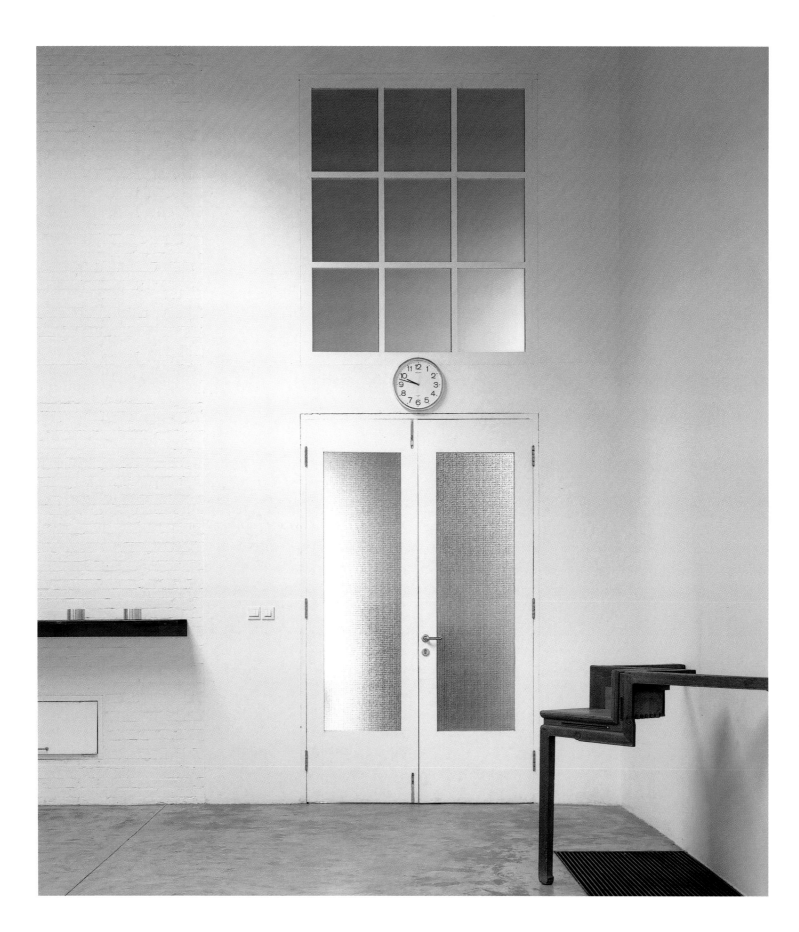

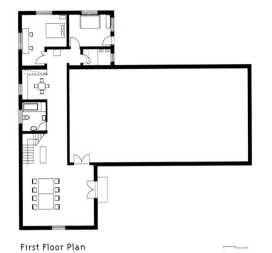

First Floor Plan

0 1 2

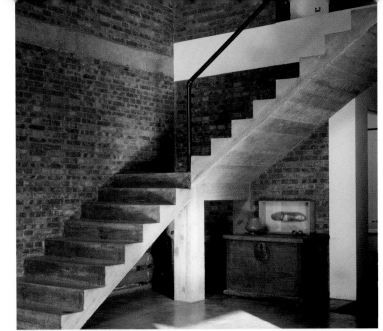

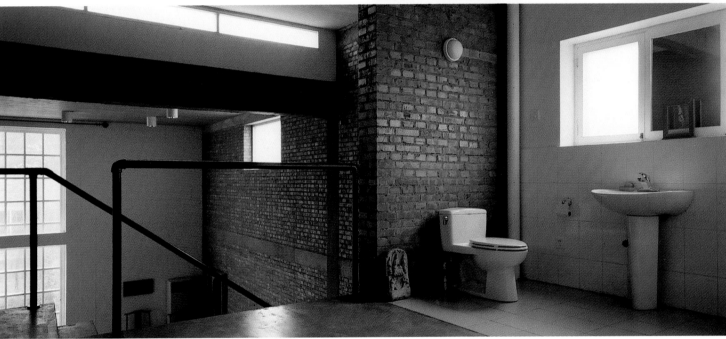

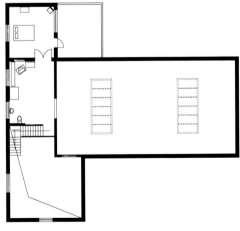

Second Floor Plan

Ai Wei Wei's
House

65

Elena Mateu Pomar

Casa A-M

Elena Mateu Pomar
e-mail: **e.mateu@coac.es**

Completion date: **2001**
Location: **Barcelona, Spain**
Floor Space: **2152 ft²**

Photographer: **Nuria Fuentes**

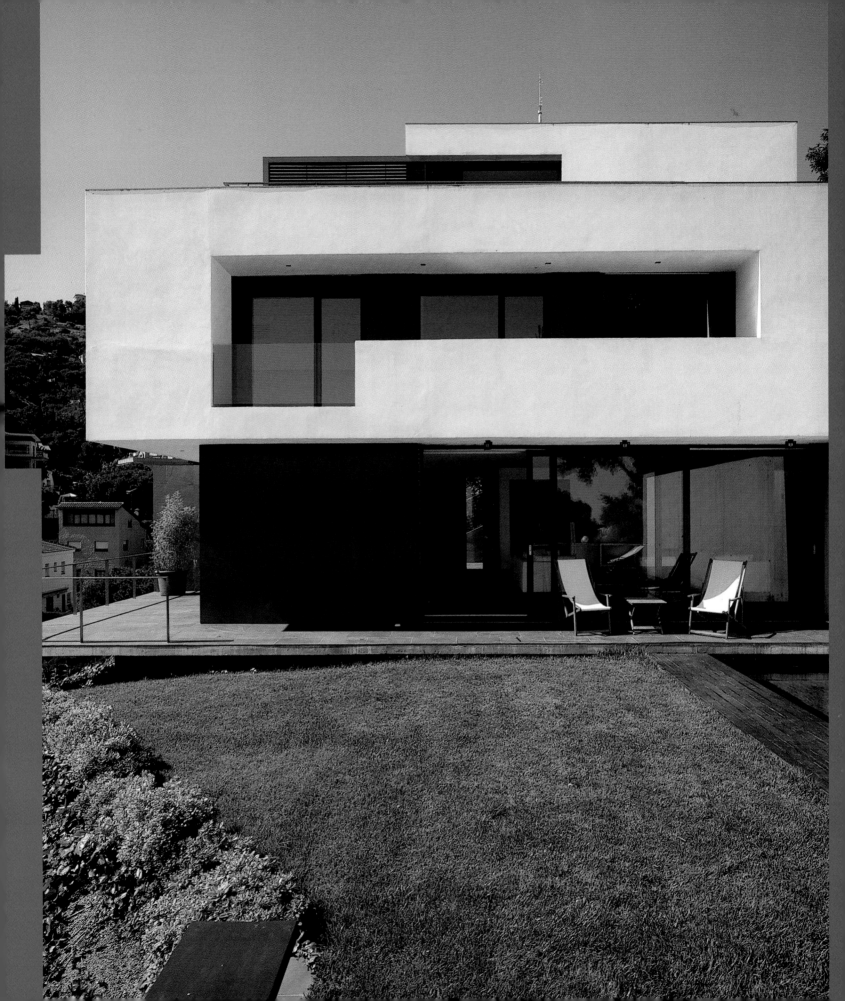

Elena Mateu Pomar was born in Barcelona, Spain in 1964. After earning a degree in architecture at Barcelona's Escola Técnica Superior d'Arquitectura, she set up her own partnership practice in the city, where she has been very active with rehabilitation and new architectural residential projects. She teaches at the Universitat Internacional de Catalunya, Barcelona, Spain.

The site of Casa A-M is situated in Montclar Street in Barcelona, on the hillside of Collserola Mountain. The plot has a triangular shape, with a marked difference, sloping 43 ft between its upper part and the street level. Despite being a large piece of land of about 10760 ft², from an urban development point of view the land was not suitable for building, hence the architect could only design a dwelling of 2152 ft² on the gradient. The architect first placed the platform, that was to be the ground floor of the house, on the upper-most part of the site, thus enabling it to gain access to the upper level in order to enjoy the scenery below. The dwellers can enter the garage of the house through a steep ramp. The ground floor level can then be reached through the exterior stairs and a tiny bridge that crosses the English patio situated on the garage level below. Once in the hall, a staircase leads to the various floors of the house. On this floor, one finds the kitchen and a living room that extends into a ter-race together with a semi-buried library lighted by means of a sec-ond patio. The upper floor incorporates the different bedrooms of the house, each with its own terrace facing south. From this level, its dwellers gain access to the back garden connected by a staircase to the swimming pool located on the ground floor. On the second floor, a large studio room, belonging to the daughters of the house own-ers, boasts a large terrace where one relishes in the astounding vis-tas of Barcelona. **«**

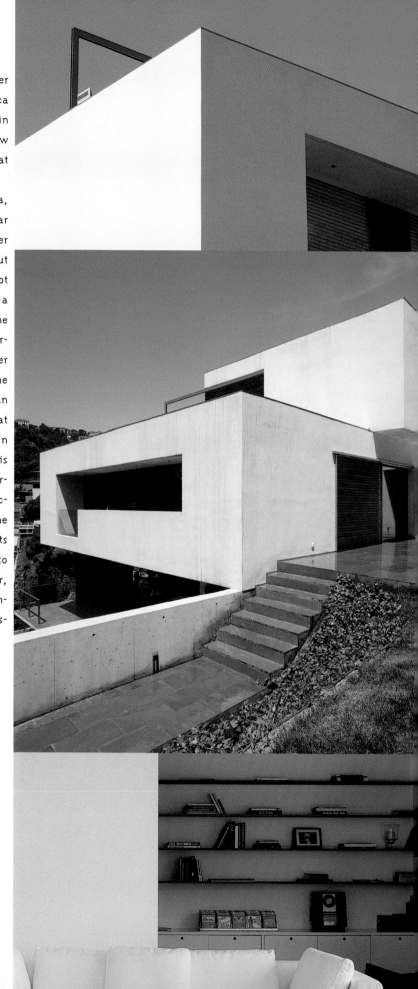

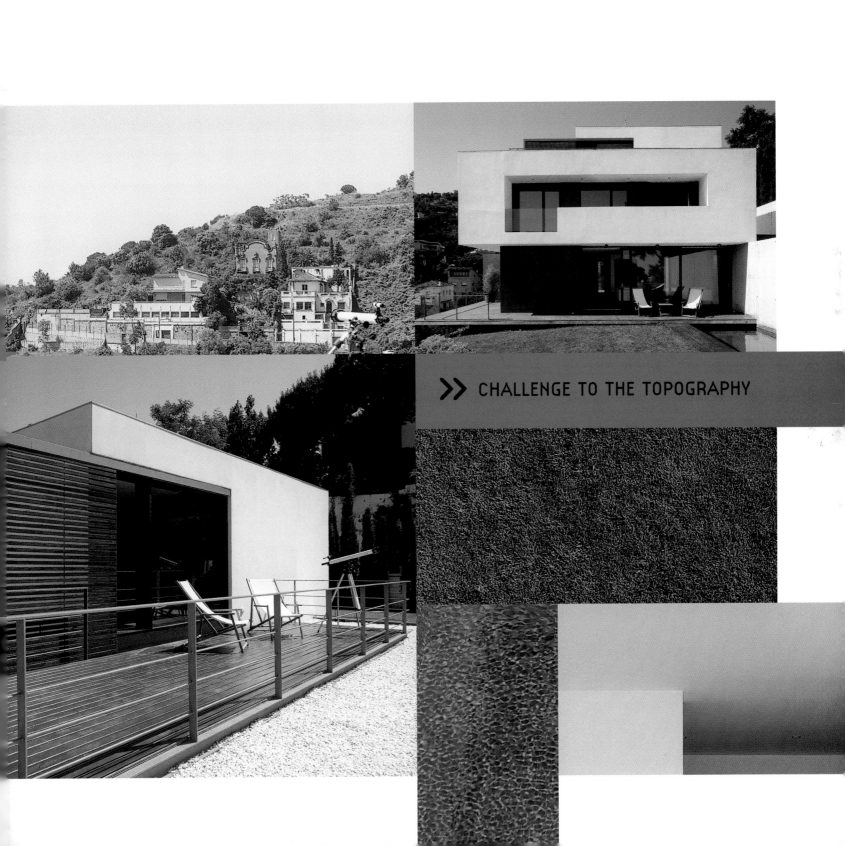

>> CHALLENGE TO THE TOPOGRAPHY

Section

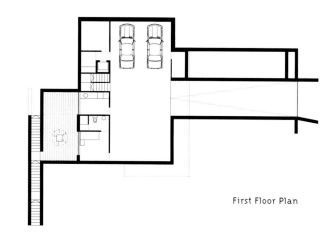

First Floor Plan

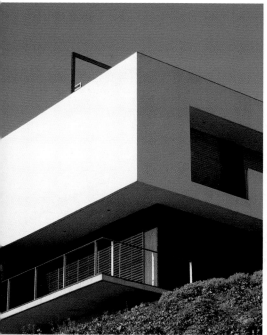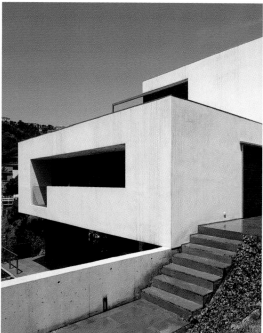

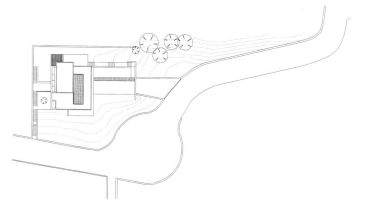

Site Plan

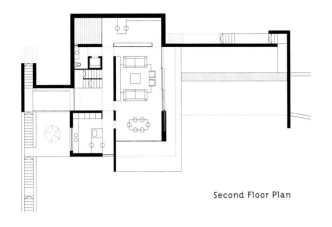

Second Floor Plan

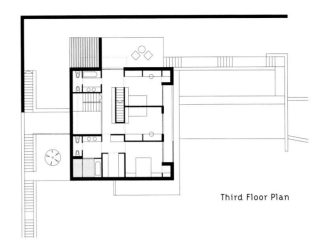

Third Floor Plan

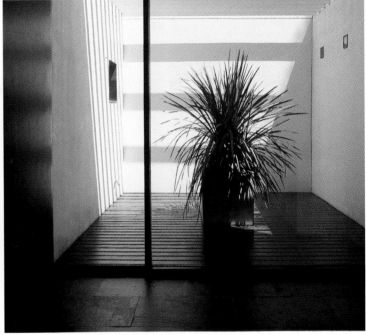

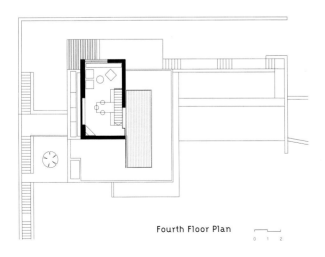

Fourth Floor Plan

0 1 2

Casa A-M

71

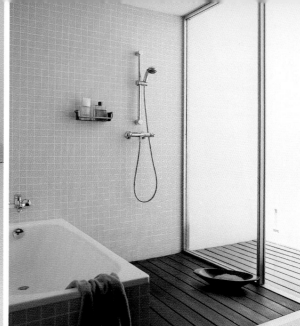
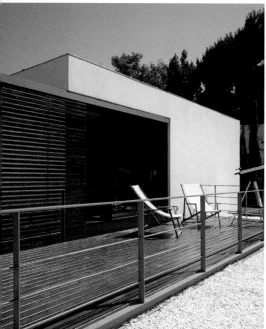
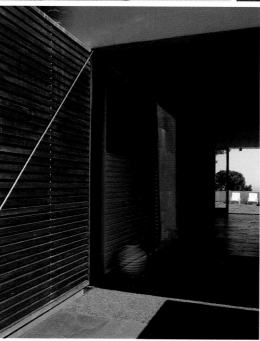
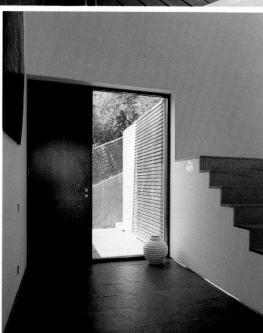

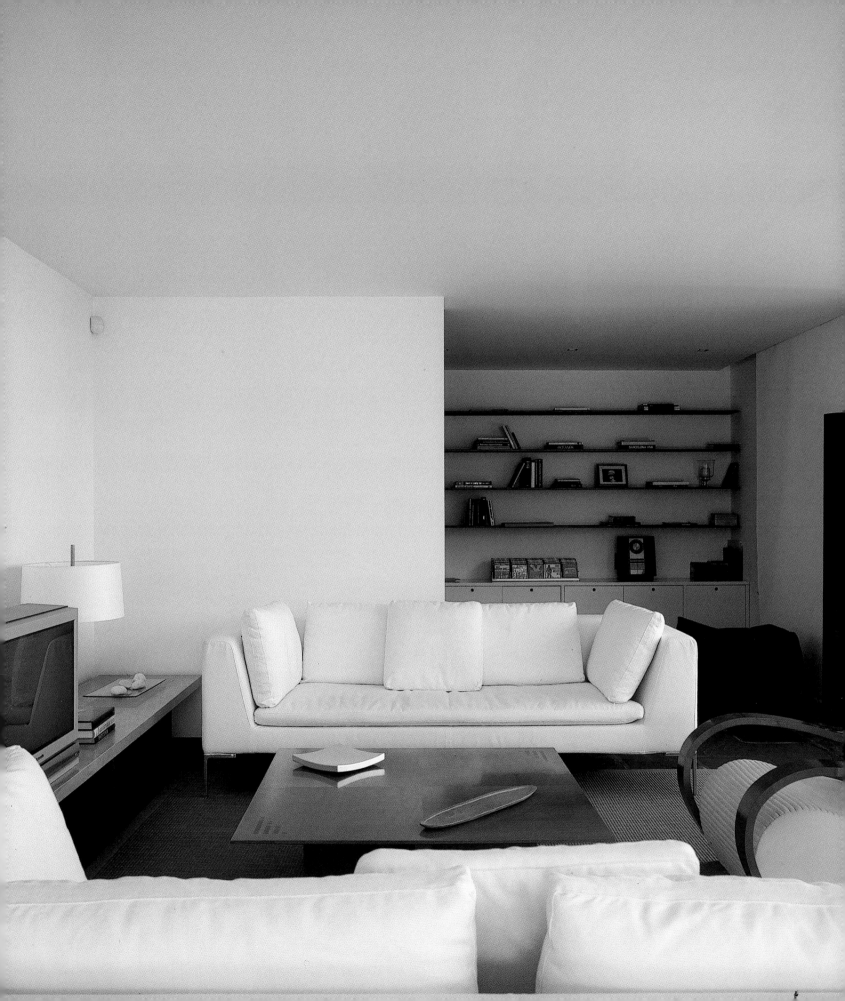

EOA

Alexander Residence

EOA / Elmslie Osler Architect
e-mail: **mail@eoarch.com**
url: **www.eoarch.com**

Completion date: **2001**
Location: **Southampton, New York, USA**
Size: **2000 ft²**

Photographer: **Eric Laignel**

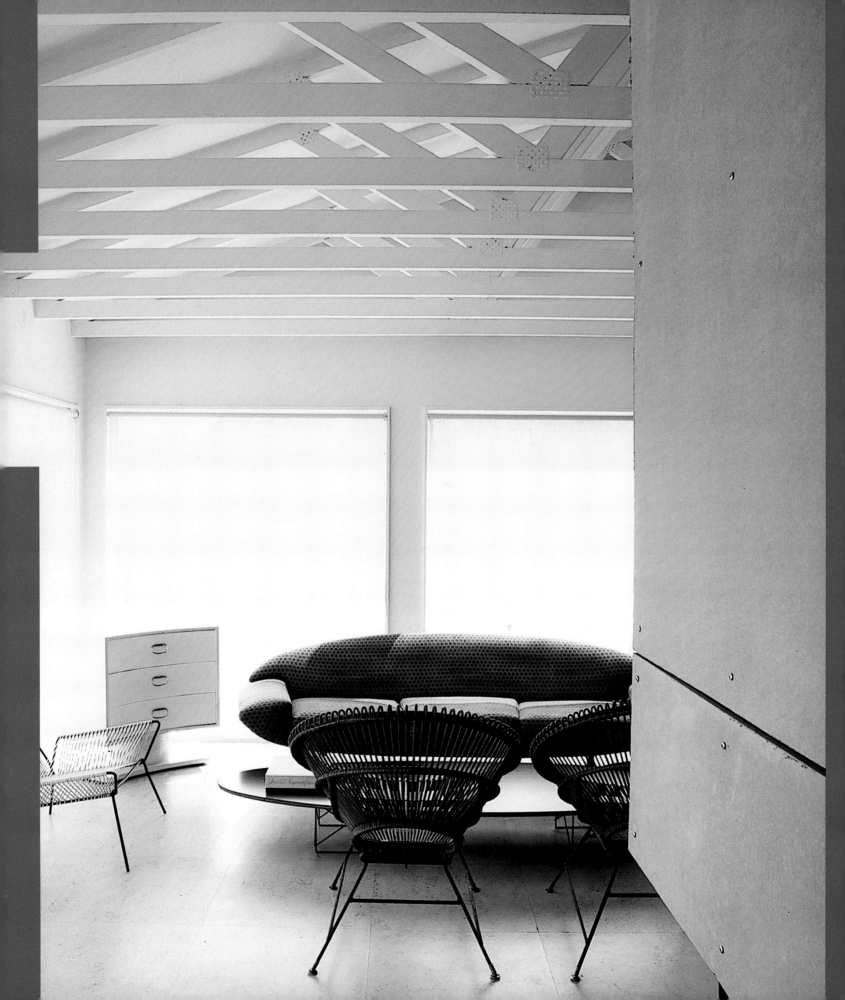

For architect Robin Elmslie Osler, who runs her own firm, EOA, one of the things that she always liked about having the family furniture is that it has the patina of her family's life on it. "There is an element of intimacy to the things that we own", she contends. The architect comes naturally by her design talents, as well as her modern furniture. Her great-uncle was Prairie School architect George Elmslie, her grandfather, Emil Lorch, founded the architecture school at the University of Michigan, and her parents filled their home with Knoll and Herman Miller furniture.

Jack Alexander, the owner of this house, is a fashion show consultant in New York City, who also swims competitively on the amateur circuit. He commissioned the architect the complete renovation of an existing cedar-shingled ranch house from the sixties, set on a hill overlooking Shinnecock Bay, to extend and connect the residence to the site. The exterior was transformed, according to the architect, by sheathing the house cement board panels and integrating a lap pool into the master plan. The plan, section, elevations, and material applications all serve to emphasize the house's relationship to its dramatic surroundings. The interior is linked to the landscape with new window openings that frame views and natural elements. The fusion of inside and outside is emphasized through continuity of materials; the chimney that runs trough the entire house is encased in the same cement board used on the exterior facade; and horizontally, the connection is made by continuing tile from the kitchen floor onto the exterior terrace. Transparency is expressed through a view encased by the front bay window and its reflection. A window beyond, while exposed trusses slip over the structure, ties the front to the back and vertically expands the interior space. The house has metamorphosized into a structure that embraces the landscape by dematerializing the line between the inside and outside, and by enriching the experience of the inhabitant and their relationship to the site. **«**

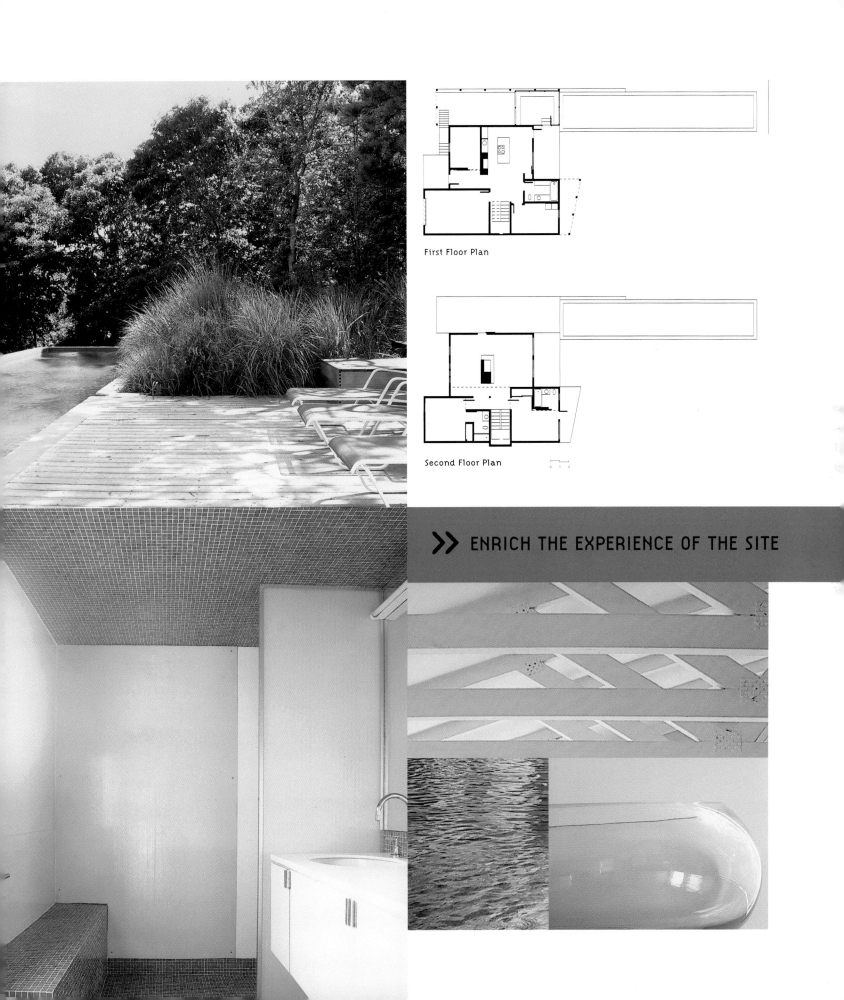

First Floor Plan

Second Floor Plan

0 1 2

>> ENRICH THE EXPERIENCE OF THE SITE

Site Plan

>> An interior linked to the landscape. The fusion of interior with exterior is further emphasized through the continuity of materials.

David Adjaye
Adjaye / Associates

Dirty House

David Adjaye - Adjaye/Associates
e-mail: adjaye@adjaye.com
url: www.adjaye.com

Completion Date: 2002
Location: London, UK
Floor Space: 3766 ft²

Photographer: Lyndon Douglas

David Adjaye was born in 1966, in Dar-Es-Salam, Tanzania. A graduate of the London's Royal College of Art, David Adjaye started a small practice in 1994 in London. In five years, he had built a reputation in the UK as an architect with an artists vision. The architectural community and the wider public have a high regard for his bespoke design and ingenious use of materials based on many of his published projects. Adjaye supports his status as a role model for young people by lecturing frequently. He has given public lectures at Harvard's Graduate School of Design, at the Architectural Association in London, at Cambridge University, and seminars at Cornell University. He trained at David Chipperfield Architects and Eduardo Souto de Moura Architects.

David Adjaye designed Dirty House by rebuilding a warehouse for its owners, artists Sue Webster and Tim Noble, to provide studio space suitable to house the artists´ large scale works as well as a permanent home. The name "Dirty House" comes from one of the artists´ work, "Dirty White Trash (with Gulls)." As seen from the exterior, the Dirty House is composed of two main elements. In order to begin with a free volume, Adjaye removed the structure thus, taking the load off of the residential floor and followed the same pattern as its predecessor. He then built additional support into the interior walls of the studio spaces. The existing window openings have been reused, as have the ground-level doorways. On the residential floor, the centre of the plan is occupied by the main living area, while the smaller spaces—the kitchen, bathing area, bedroom, and terraces to the south and west—are located in a peripheral band. The centralized character of this arrangement is given further emphasis by a skylight in the middle of the section and the cantilevered roof. The skylight itself provides a level of natural light similar with being outside. In designing the Dirty House, the architect's own words apply, when saying that his design "attempts to reconcile the institutional scale of a museum with the intimate scale of a house." 《

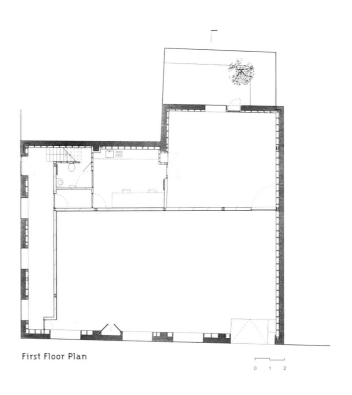

First Floor Plan

0 1 2

>> MAKE SPACE PRESENT
MAKE IT INTENSE

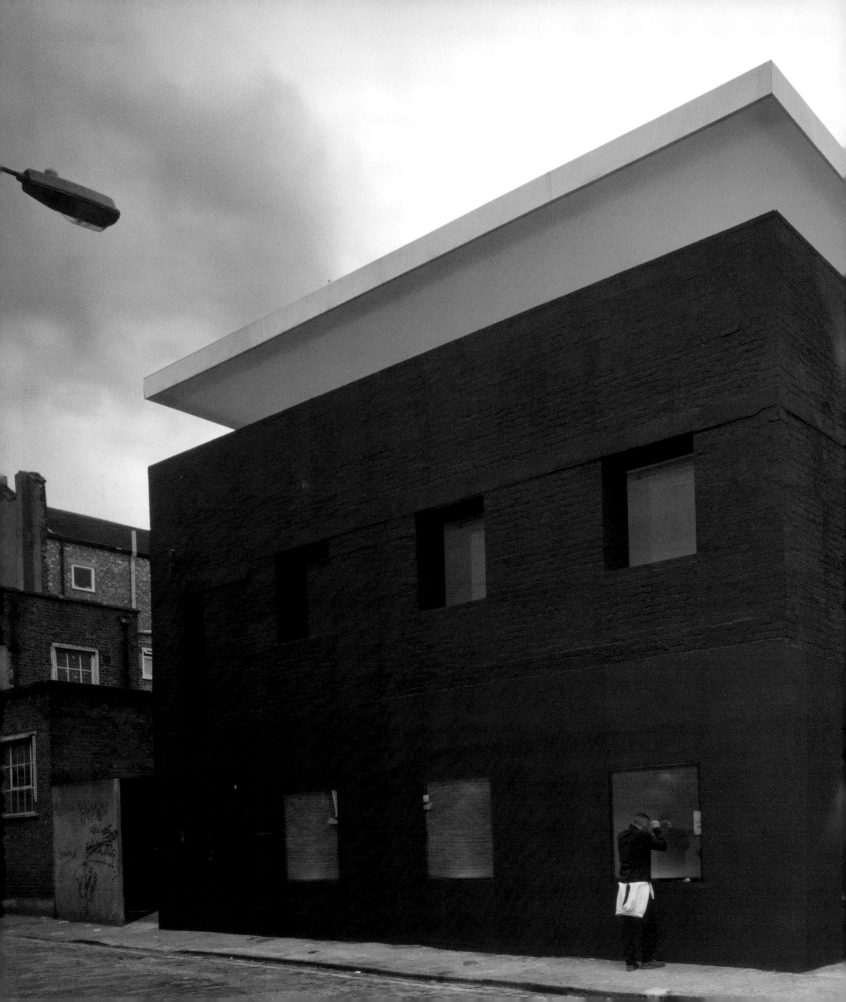

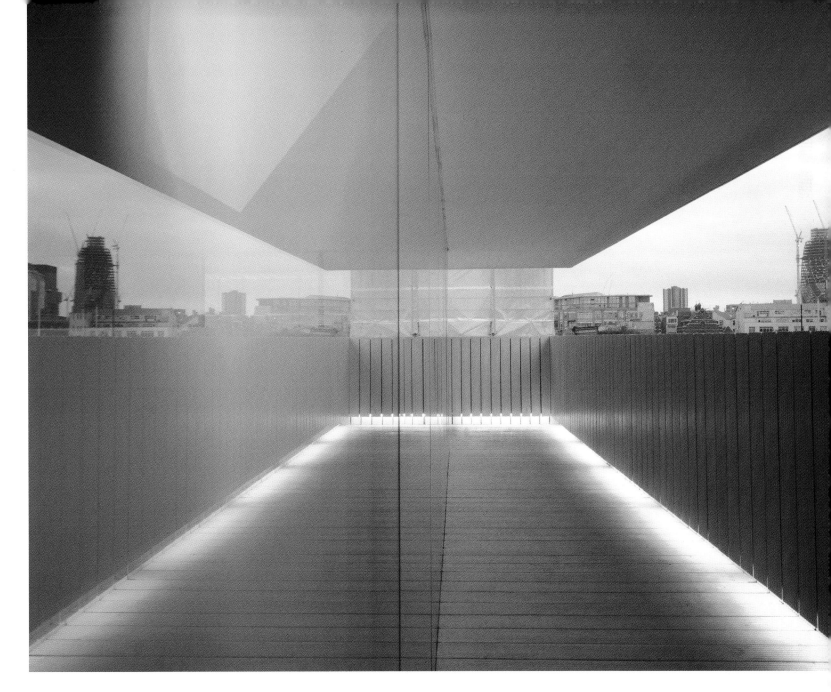

Left: The old wall has been coated in a thick chocolate-cake color anti-graffiti paint with its seemingly floating cantilevered roof.

Mirror window view of the balcony with London´s burgeoning crop of skyscrapers.

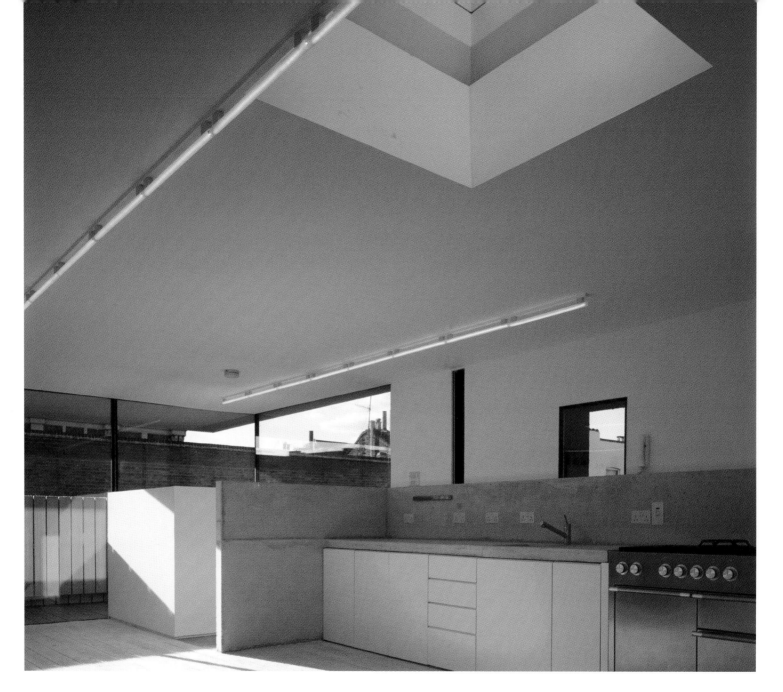

The owners live on the upper part of the building. Impressive combination of the lighting with a skylight in the kitchen and the dining areas.

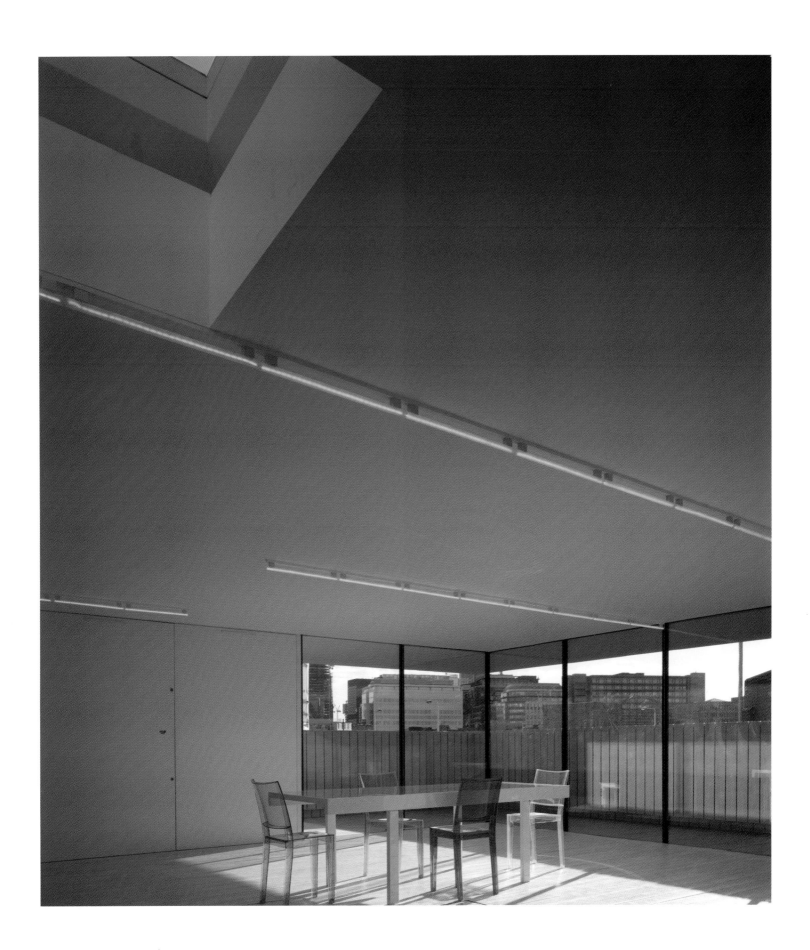

>> While the studio space is impressively ample, the living space is relatively compressed.

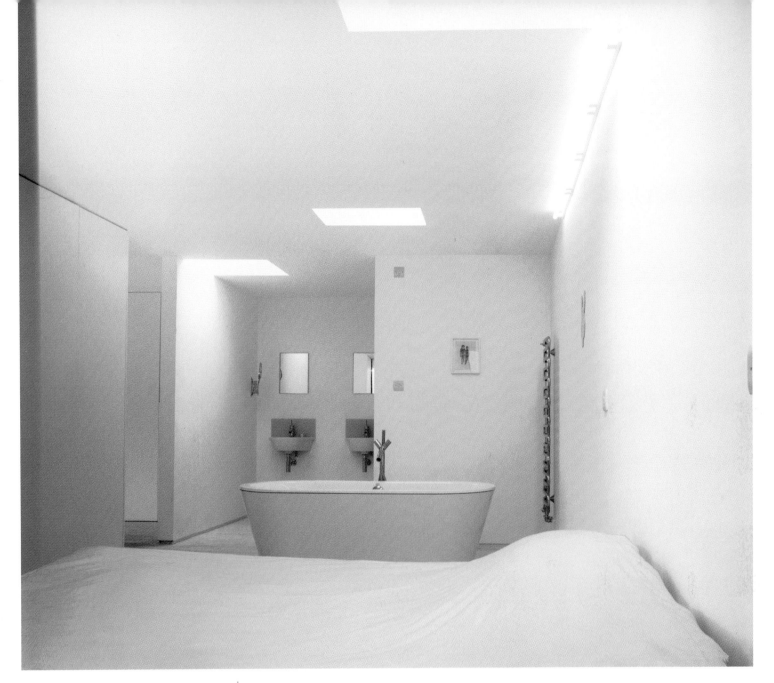

Third Floor Plan

Second Floor Plan

90

99

Shigeru ban

Picture Window House

Shigeru Ban Architects
e-mail: SBA@tokyo.email.ne.jp
url: www.dnp.co.jp/millennium/SB/VAN.html

Completion date: 2002
Location: Izu, Shizuoka, Japan
Floor Space: 2946 ft^2

Photographer: Hiroyuki Hirai

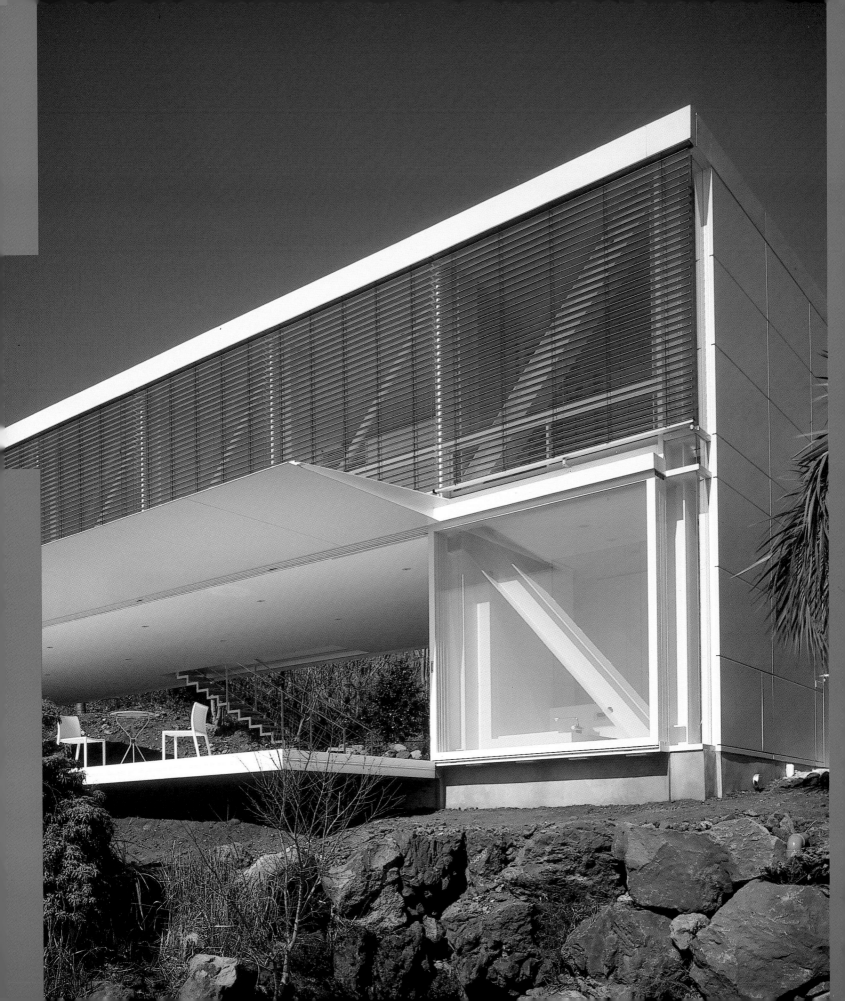

Shigeru Ban was born in Tokyo, studied at the Southern California Institute of Architecture (SCI-ARC), and earned a Bachelor of Architecture degree from The Cooper Union for the Advancement of Science and Art, New York.

Having established his own private practice in 1985, Shigeru Ban focuses on material and structural experimentation, striving to produce innovative solutions that result in iconic projects. Among the 20+ houses designed by the architect, the most notable, the "Curtain Wall House," became the iconographic image for MoMA's "The Un-Private House" exhibition in 1999. In Japan, the architect won the Kansai Architectural Grand Prize (1996) and the Best Young Architect of the Year (1997).

Shigeru Ban's work is characterized by the innovative use of unexpected materials and the humanitarian spirit with which he works. An example of this philosophy may be found in his own words: "Even in disaster areas, as an architect I want to create beautiful buildings. I want to move people and improve people's lives. If I did not feel this way, it would be impossible to create meaningful architecture and to make a contribution to society at the same time."

In the Picture Window House, the architect continues with his design philosophy to create a free and open space with a concrete rationality of structure and construction.

Using as primary materials galvanized steel, aluminum paneling, glass in its exterior, and gypsum board in its interior, the house, located at the peak of a gentle hill that continues up from the ocean's edge, benefits from a site that, amazingly in Japan, is uncluttered by any unsightly distractions.

According to the architect, when he first set foot on the site his immediate response was to frame the wonderful view of the ocean stretching horizontally. By that, he meant that the building itself should become a picture window. Also, in order to prevent the architecture from becoming an obstacle disrupting the natural sense of flow from the ocean, Ban thought of maintaining that continuity by passing it through the building up to the woods at the top of the hill. Thus, the whole upper story became a truss spanning 65.6 ft, and below a 65.6 ft by 8.2 ft picture window was created. ≪

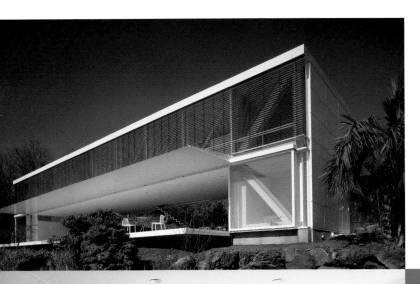

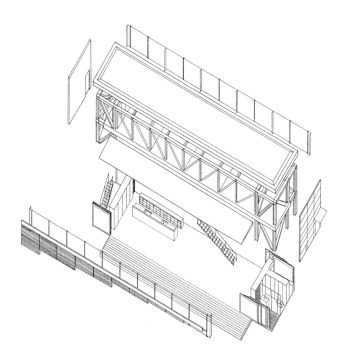

Axonometric

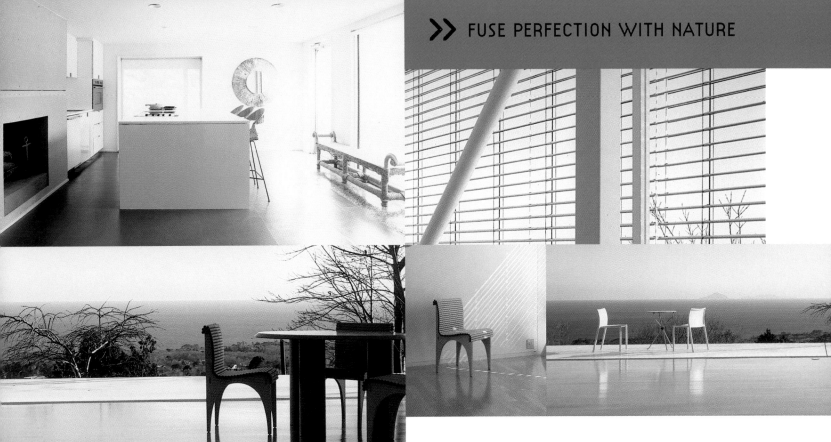

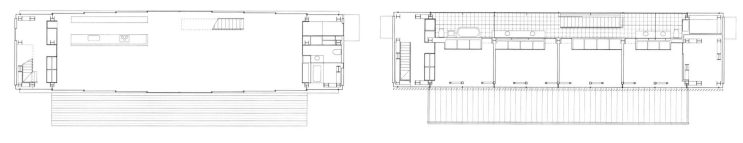

First Floor Plan Second Floor Plan

0 1 2

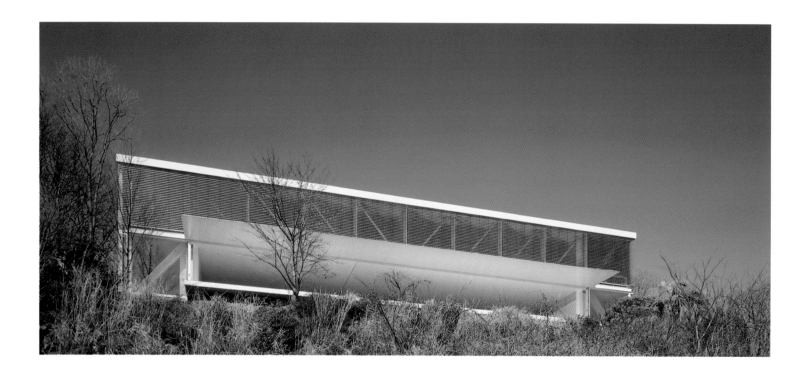

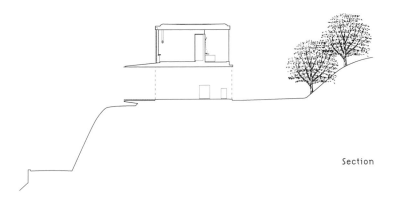

Section

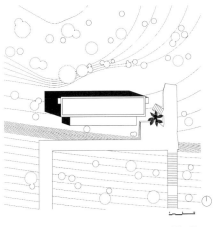

Site Plan

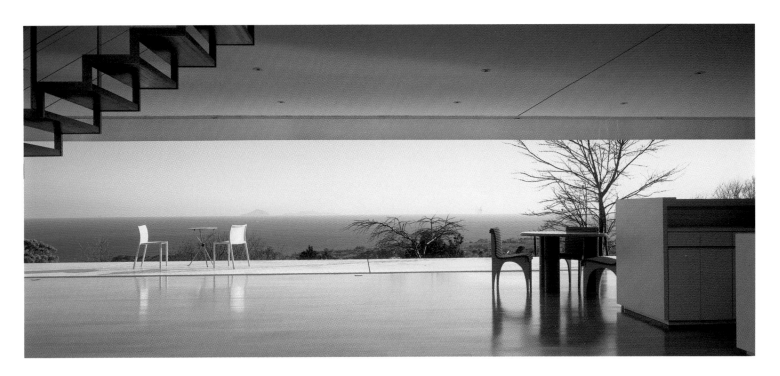

>> View of the Pacific Ocean from the living room.
This lower floor is totally integrated with nature.

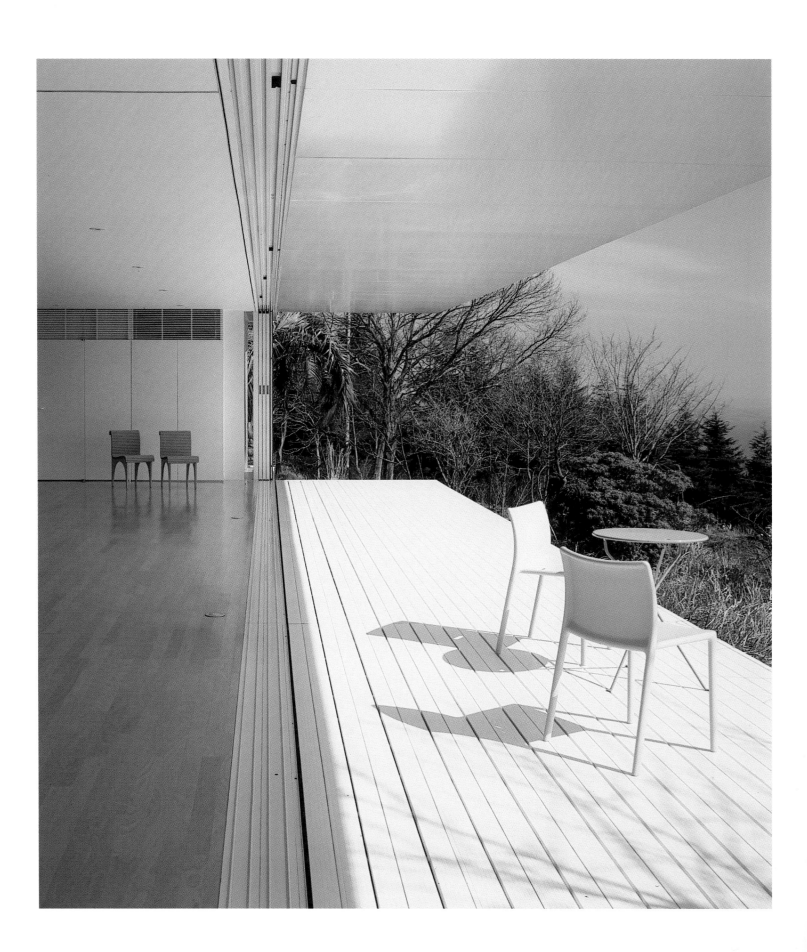

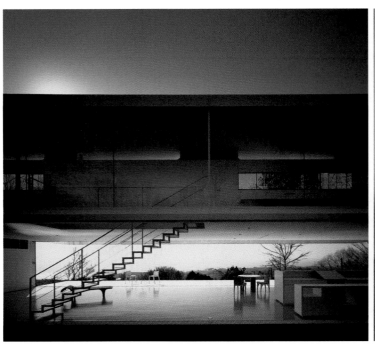 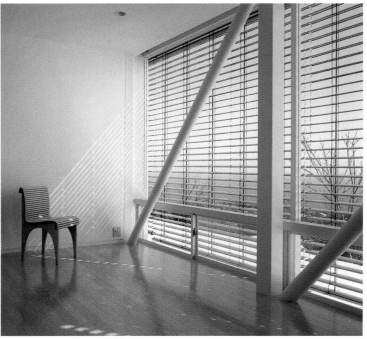

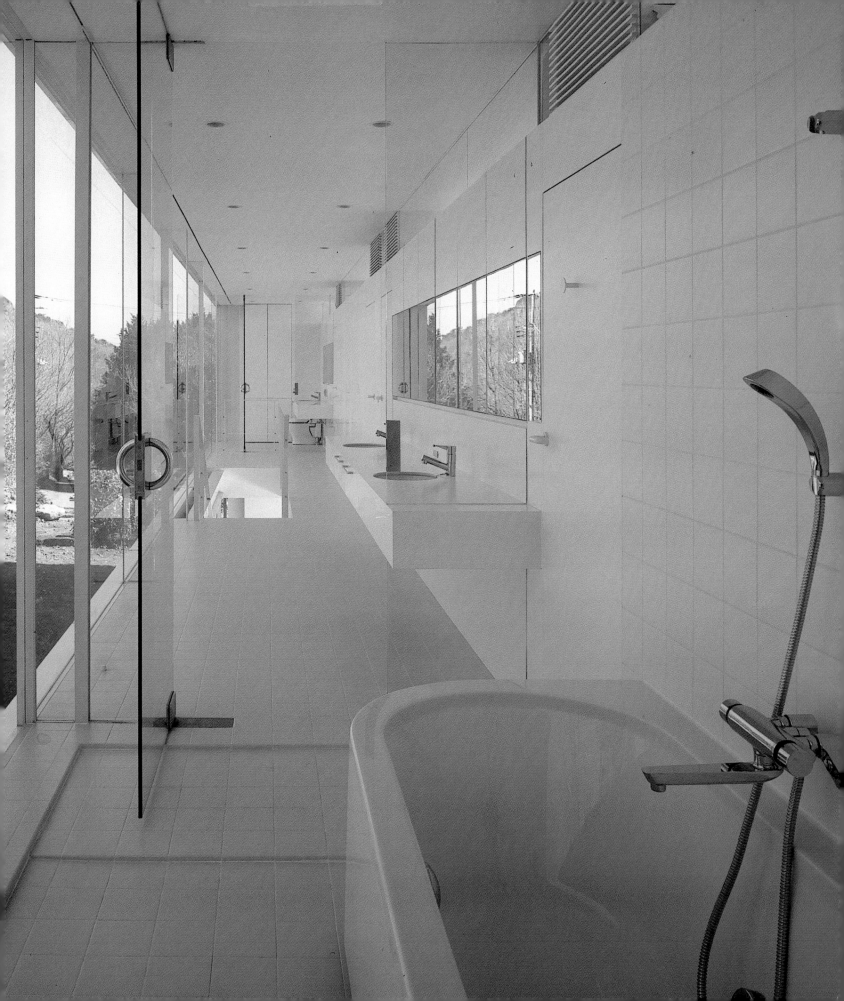

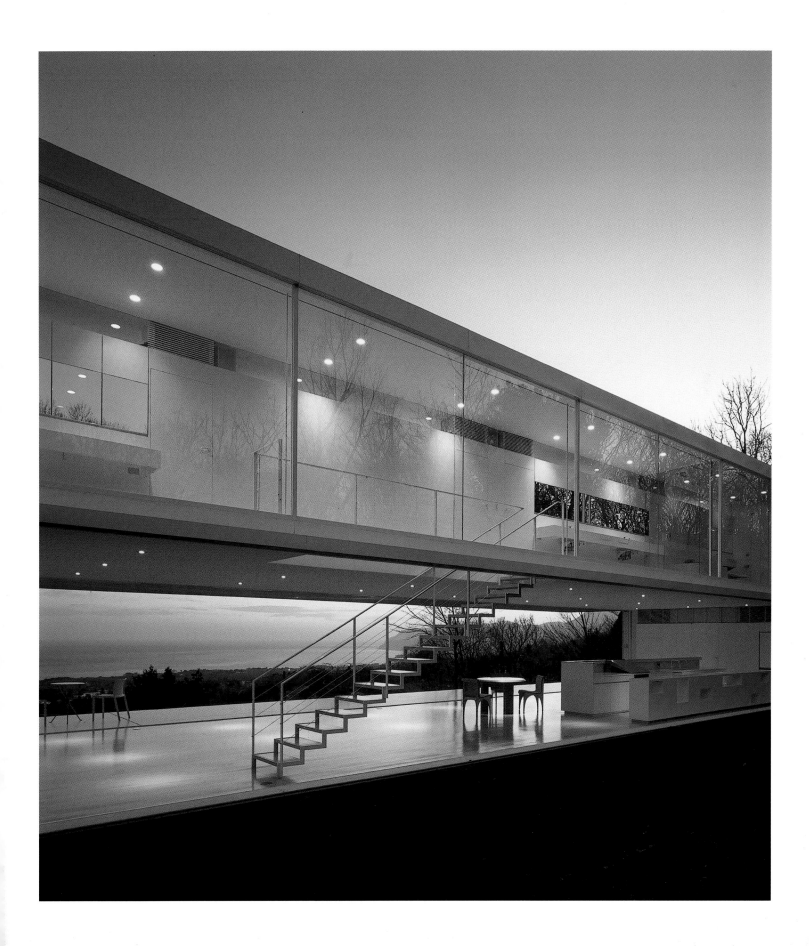

Gillett Klinkowstein Residence

EOA / Elmslie Osler Architect
e-mail: mail@eoarch.com
url: www.eoarch.com

Completion date: **2000**
Location: **Tribeca neighborhood of New York City, NY, USA**
Floor Space: **2500 ft²**

Photographer: **John Hall**

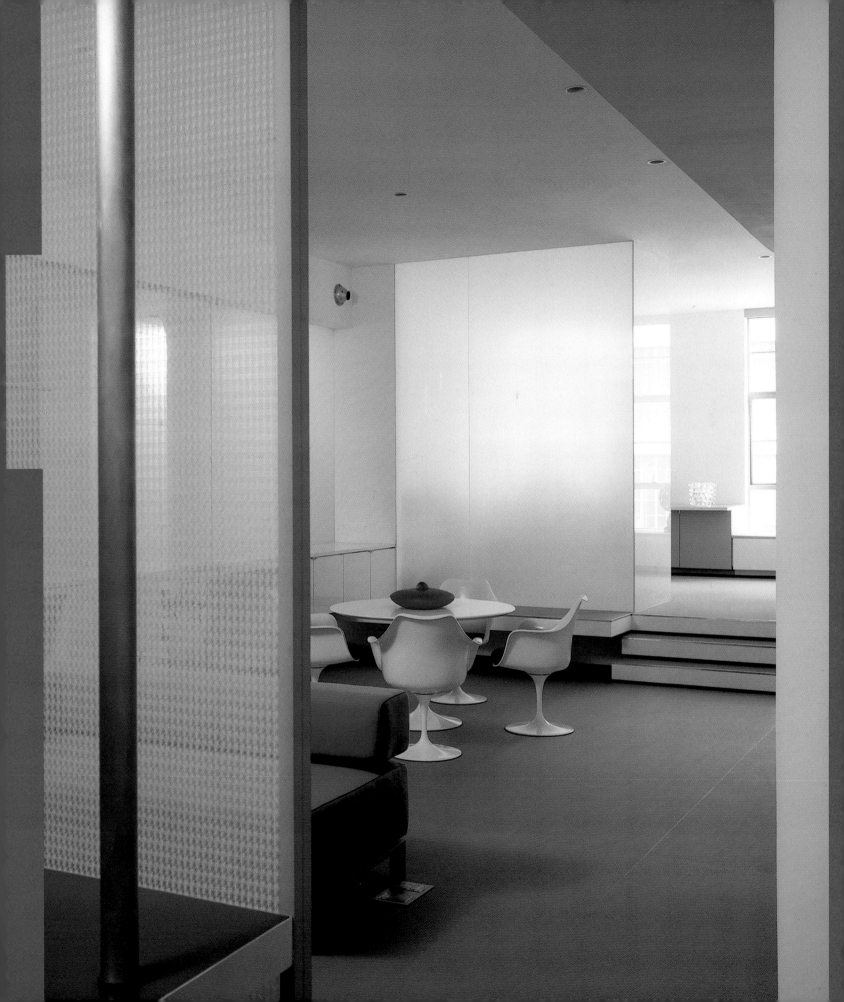

According to EOA, its work seeks to expand the experience beyond the harmonics of proportion and scale to include the harmonics of surface and materiality, light and shadow, and translucency and opacity. Robin Elmslie Osler´s objective is to develop an architecture that uses mystery to mediate past memory with future possibility through work informed by this tension between fulfillment and promise. Projects are charged with seductive hints of clarity by teasing the intellect with unanticipated uses of materials. Implied transparencies and veiled views toy with clarity of perception . To temper the logical with the more intuitive content of the client´s desires, initial explorations often segue through the fields of art, literature, cinema, music, and fashion. In regard to the Gillett Klinkowstein architectural project, the object was, according to Robin Elmslie Osler, to design a residence for the couple, Tom Klinkowstein (a new media professor and a media consultant with his own company, Media Arts) and Elisabeth Gillett (a designer of accessories who has her own eponymous company). By the nature of their respective interests, there was a juxtaposition of "soft" and "hard" sensibilities to be resolved. Light entering the space was minimal and from only one side. The fusion of the two sensibilities is achieved, argues the architect, through the materials that also serve to reveal the light. The light infiltrates the space through a series of layers of translucent glass and screens of hogwire. The glass is rigid but its translucency is yielding. The hogwire is woven from flexible plastic but its density and three-dimensional braid feels stiff. The translucent surfaces become opaque, depending on the shifting light and movement of the inhabitants. The space is activated by the layers and by their variability, thus creating a sense of depth and luminosity. 《

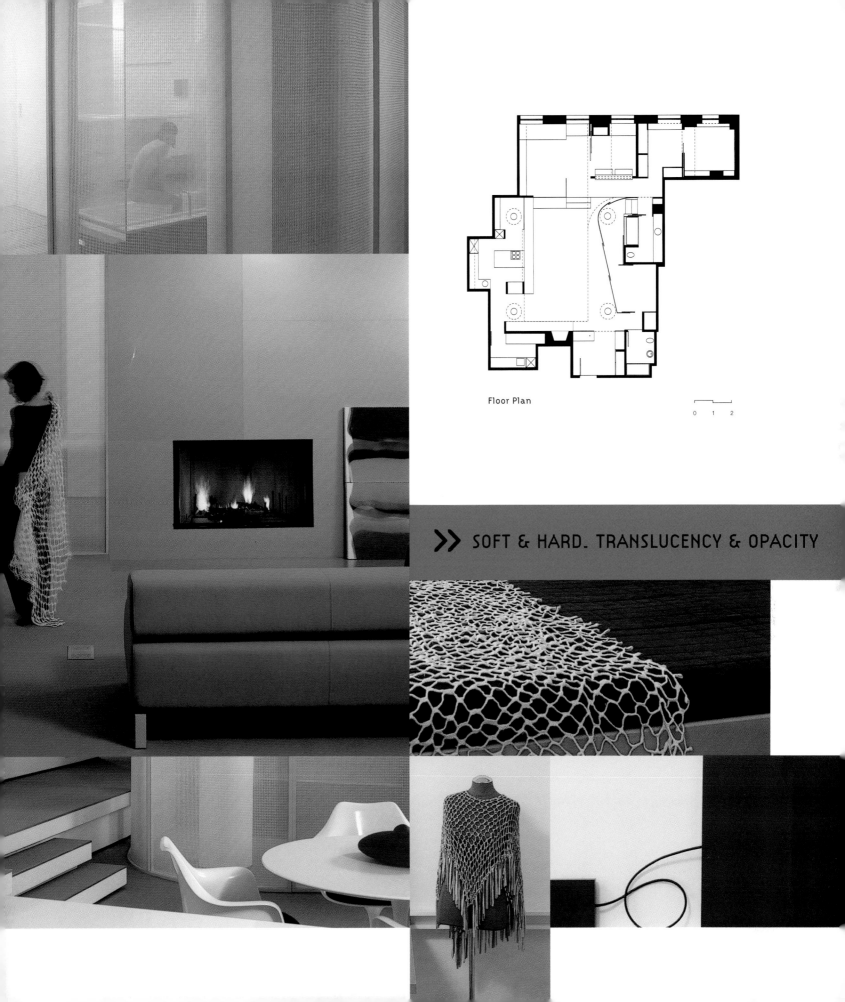

Floor Plan

0 1 2

>> SOFT & HARD. TRANSLUCENCY & OPACITY

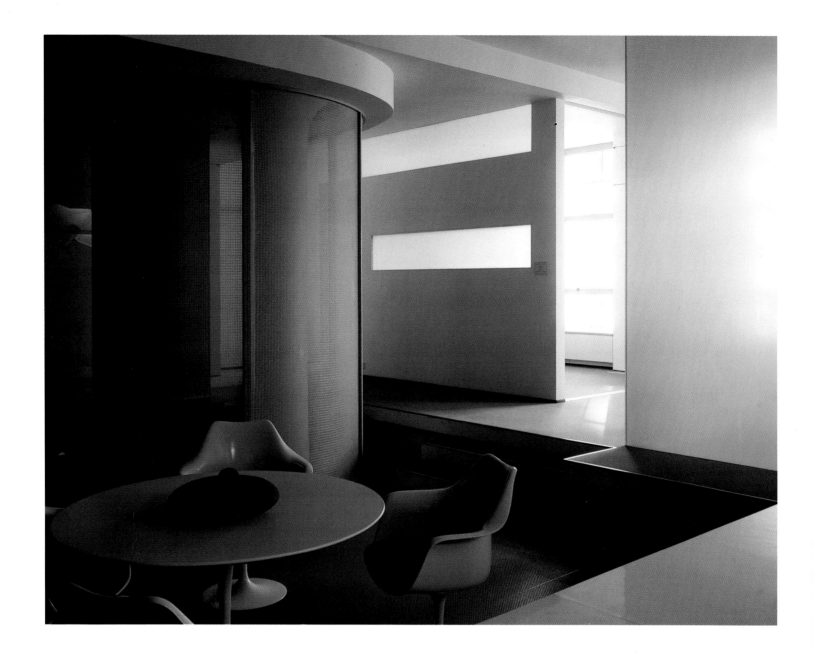

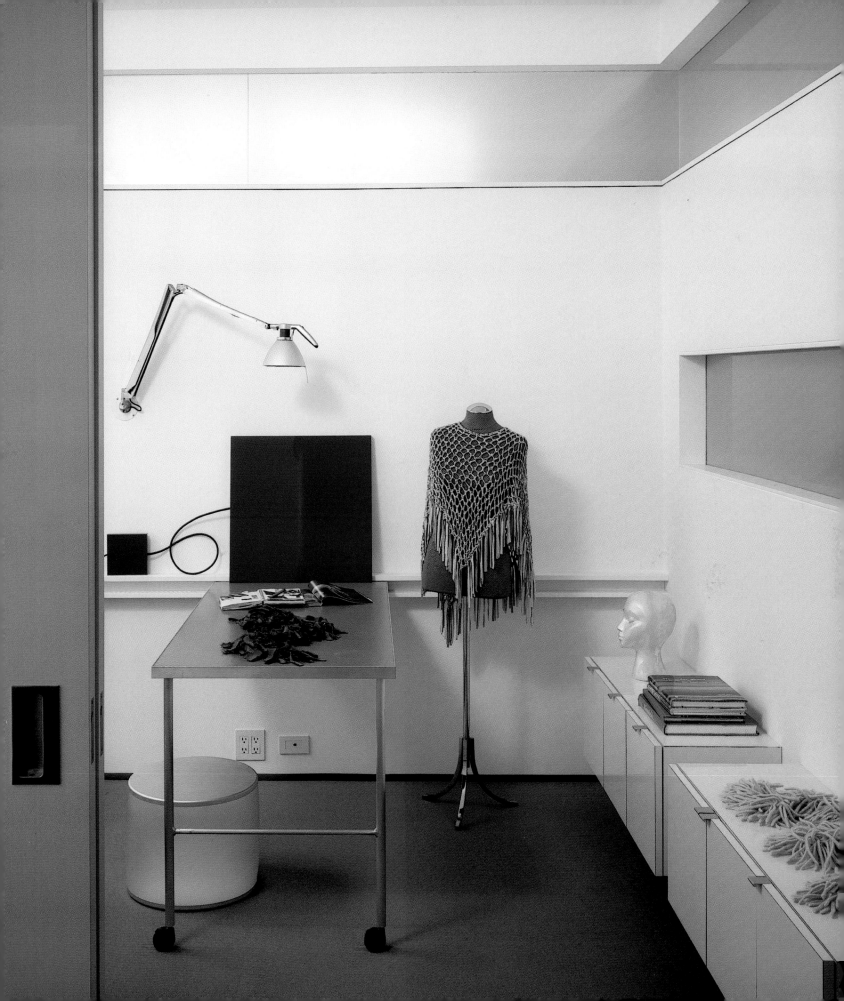

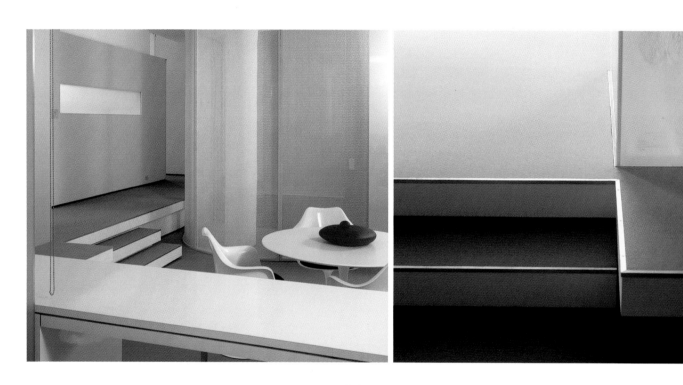

>> Detail of the kitchen and dining areas. The perfect finishings of its interior details gives order to the space.

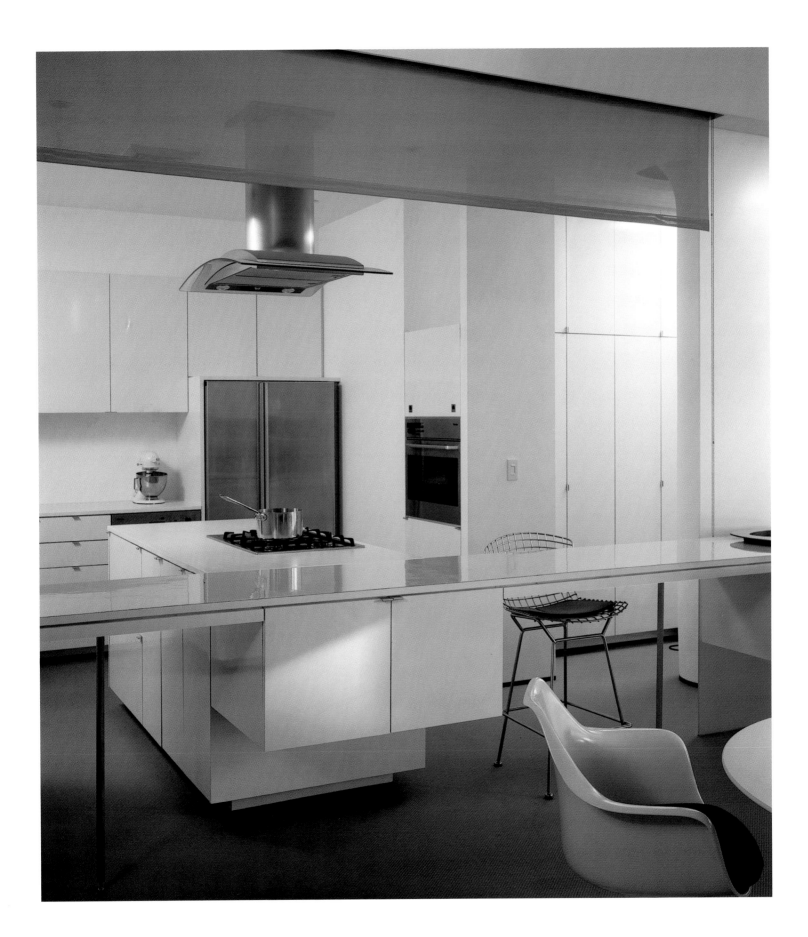

To stress the difference among textures, such as transparency and translucency, a net and a lattice are incorporated effectively.

Seung, h-Sang

Subaek-dang

Seung, H-Sang / IROJE architects & planners
e-mail: iroje@iroje.com
url: www.iroje.com

Completion date: 1999
Location: Hwadoeup, Namyangjukun, Kyoungido, South Korea
Floor Space: 2152 ft²

Photographer: Osamu Murai

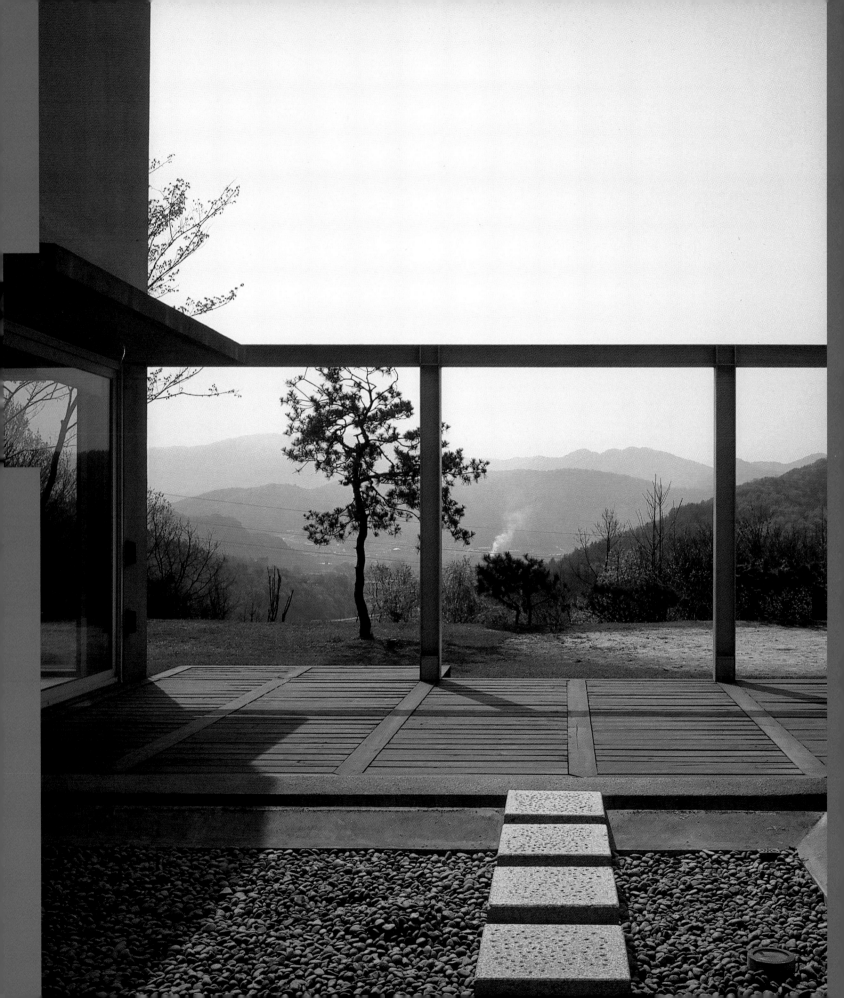

Hchioh Sang Seung, born in 1950, studied at Seoul National University, South Korea. He established his own firm, IROJE architects & planners, in 1989. His architecture which has received numerous awards, is based on the theory of "Beauty of Poverty" that both criticizes and embraces the banal conditions of present-day architecture in Korea. Seung teaches at Seoul National University. The Korea National Museum of Contemporary Art selected him as "Artist of the Year 2002," the first time this award is given to an architect.

The clients of Subaek-dang, a middle-aged couple, were adamant that Hchioh Sang Seung should build their new house in the countryside. The 2152ft2 house, including the basement floor, is composed of twelve rooms: five interior rooms with roofs and seven outdoor rooms opening up to the sky. Whether interior or exterior, every room is independent — each in a world of its own. Although some rooms could be related to each other to form a unified space, as a principle, one room is never subordinate to the other. The rooms open to the sky are basically, according to the architect, without an apparent function. Whether they store water, or are covered with maru (wooden flooring), earth, or pebbles, in essence, these spaces are void. Likewise, the interior rooms, even those with a functional facility that carry a definite purpose (i.e., bathroom, kitchen), Seung argues, should not be understood solely by their use. The decision to distribute spaces along a 98.4 ft by 49.2 ft frame was to preclude the injection of functional aspects into each room, and their naming — the very act of specification — was only for practical reasons.

Subaek-dang is made of white materials. The architect decided to adhere to the white in this work because he believed the color would provide more room for time and life to leave their marks and traces. He also wanted to present a direct interpretation of its name (Subaek-dang actually means "white house"). Finally, economic factors played an important part in the construction as well. Moreover, according to Seung, there was no other apparent way to stress the "concept of void," a key idea in design. «

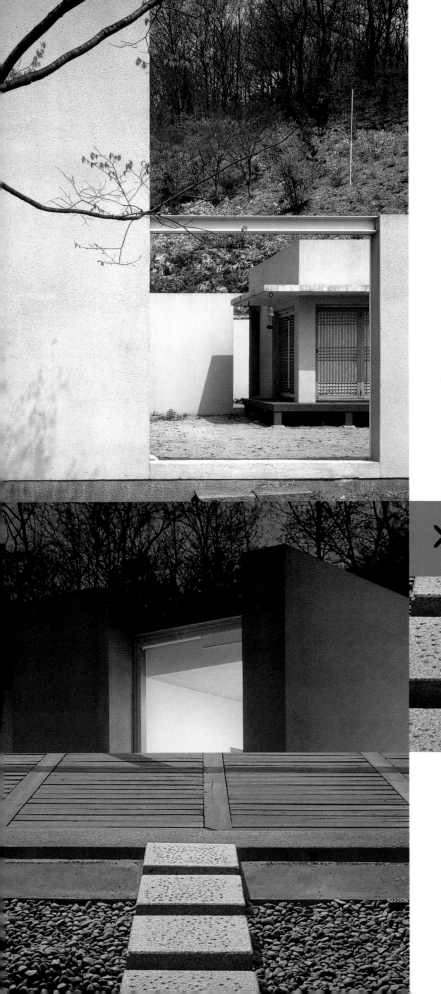

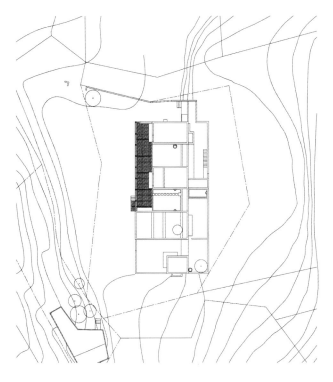

Site Plan

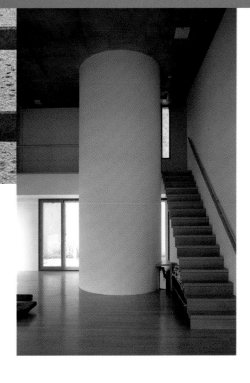

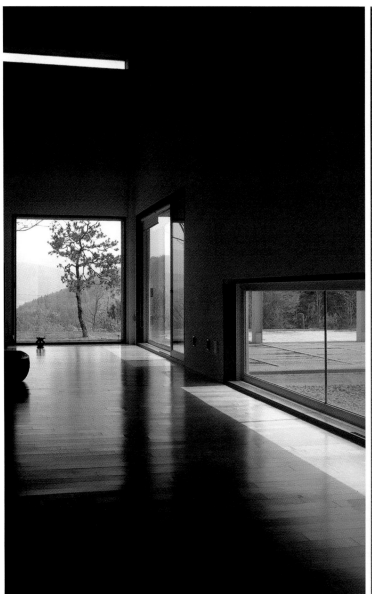
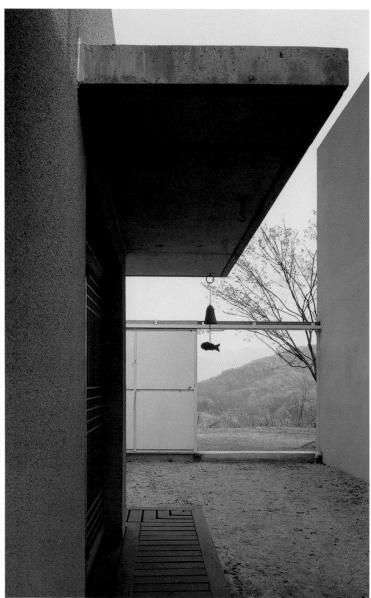

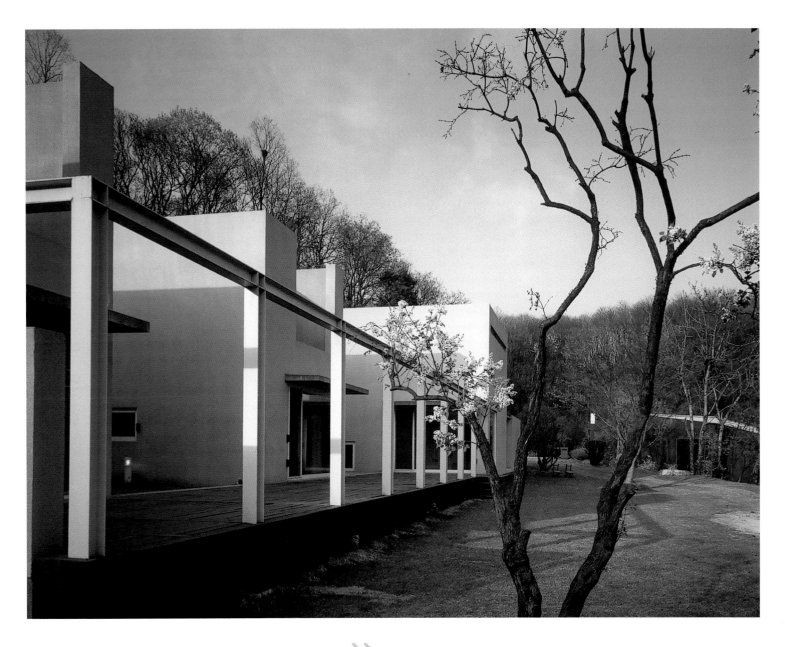

» Subaek-dang is made of a white material to stress "the void", a key word in design.

First Floor Plan

Second Floor Plan

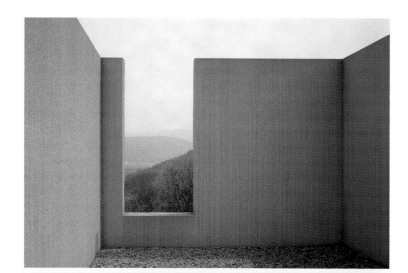

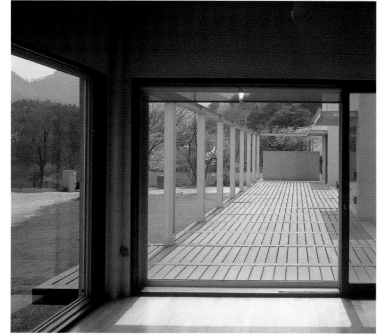

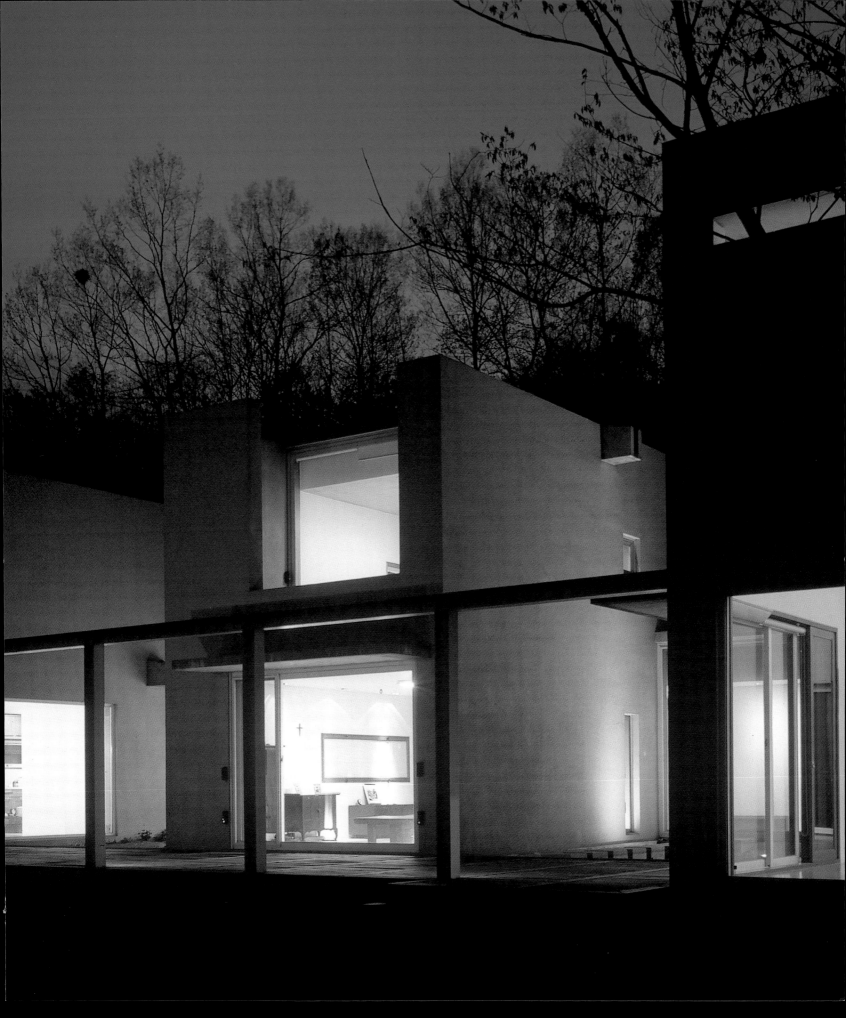

MS-31

Two Houses in San Diego

Sebastian Mariscal / MS-31 inc.
e-mail: **sebastian@ms-31.com**
url: **www.ms-31.com**

Completion date: **2003**
Location: **San Diego, California, USA**
Floor Space per house: **2750 ft^2**

Photographer: **Hisao Suzuki**

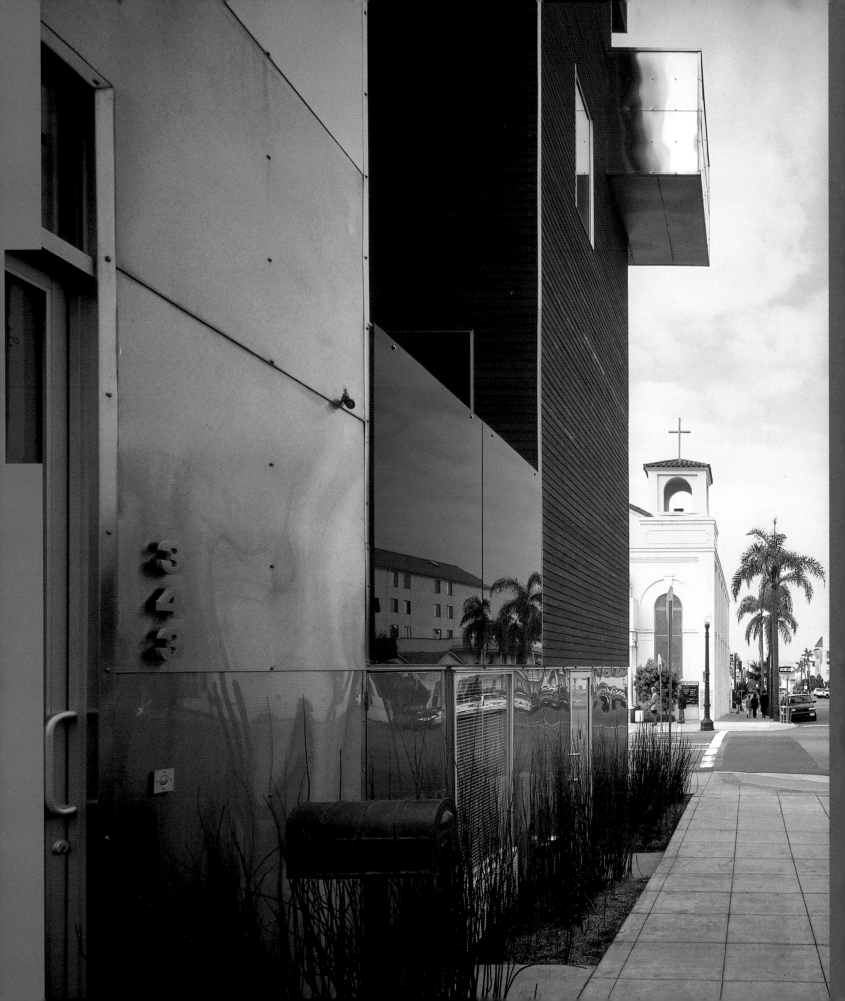

Sebastian Mariscal is from Mexico City, where he was born in 1970. He attended Universidad Nacional Autónoma de México (UNAM) from 1990-1994 and later studied at the Escola Técnica Superior d´Arquitectura de Barcelona (ETSAB) from 1995-1996. Since his career started at the age of 19, he has designed over 40 projects. Having worked with architects Alberto Kalach in Mexico City, Tonet Sunyer in Barcelona, and Jonathan Segal in San Diego, Mariscal set up his own office, MS-31 inc., in San Diego. The office, composed of three people, does everything from design to construction.

The Two Houses in San Diego were built in a little over four months. They are located in "Little Italy," a redevelopment area of downtown San Diego. Sebastian Mariscal lives in one of the homes, and his business associate lives in the other. The lot size was 1550 ft 2 and was then subdivided into two parcels, each of 750 ft^2. Each house has 2750 ft^2 of gross area. According to the architect, the zoning allowed them to build with a zero lot line, using 100% of the lot. The objective, argues Mariscal, was to build a house where he could both live and work. In the basement level there is tandem parking, the MS-31 office, one bedroom, and a bathroom. There are separate entrances to the office and to the house. On the first level is the living area, the dining room, the kitchen, and a deck. The second level is the kids' level, with two bedrooms, a playroom, a bathroom, and the laundry room. Finally, the third level incorporates the master bedroom, a bathroom, and another deck. On top of it, from the rooftop deck, its dwellers can get a clear view of downtown San Diego and a distant one of the ocean.

The structure of the two houses is wood framing (with the exterior skin being stained redwood) and stainless steel. The interior incorporates maple, hardwood floors, and stained oak cabinets and walls. According to Sebastian Mariscal, every period throughout history has posed specific challenges to architecture. MS-31 thus identifies "timing," among other challenges, as their main challenge for the twenty-first century. By attempting to keep away from subjectivity, MS-31 relies on "proper timing" and a tight control of the building processes in order to achieve a permanent evolution and the perfection of their own architecture. ≪

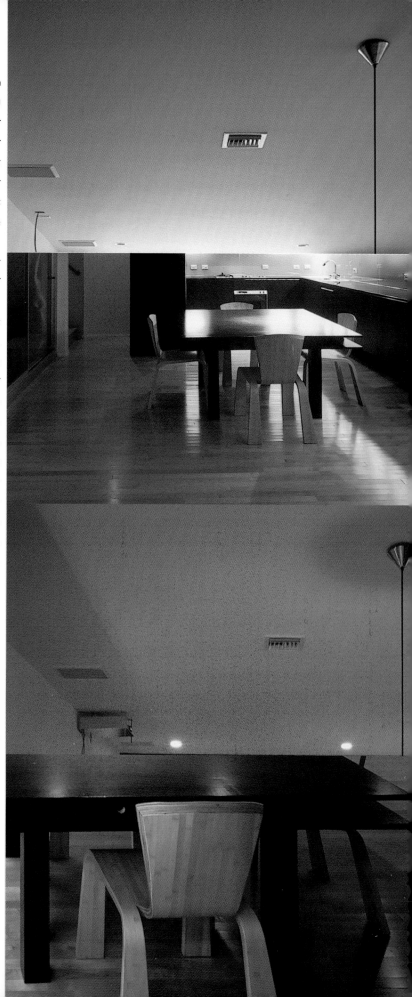

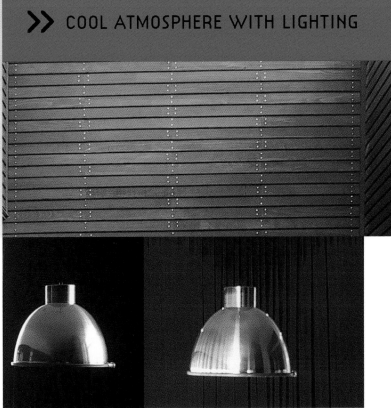

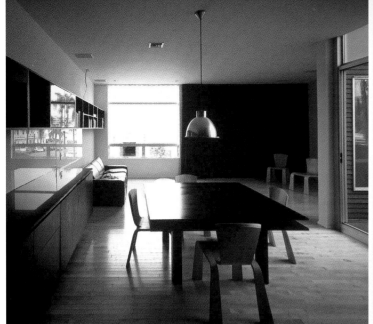
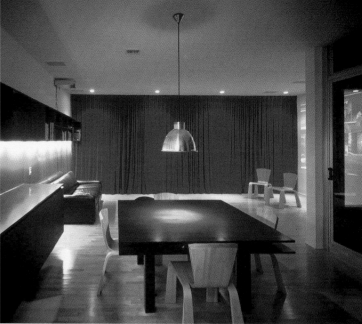
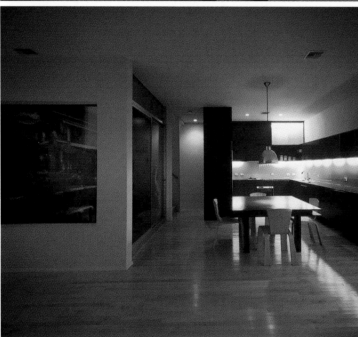
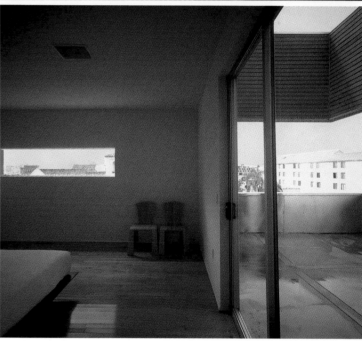

>> With its cool lighting scheme, the same space changes dramatically at daytime and night.

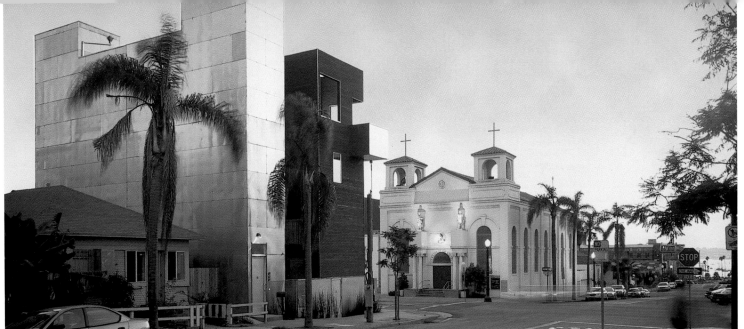

Section

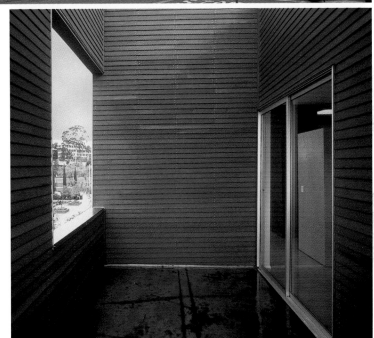

124
133

The Shared House

Commune by The Great Wall

Kanika R'kul / Leigh & Orange (Thailand) Ltd.
e-mail: info@leighorange.co.th
url: www.leighorange.co.th

Completion date: **2002**
Location: **Shui Guan Mountain, North of Beijing, China**
Floor Space: **5633.72 ft²**

Photographer: **Satoshi Asakawa**

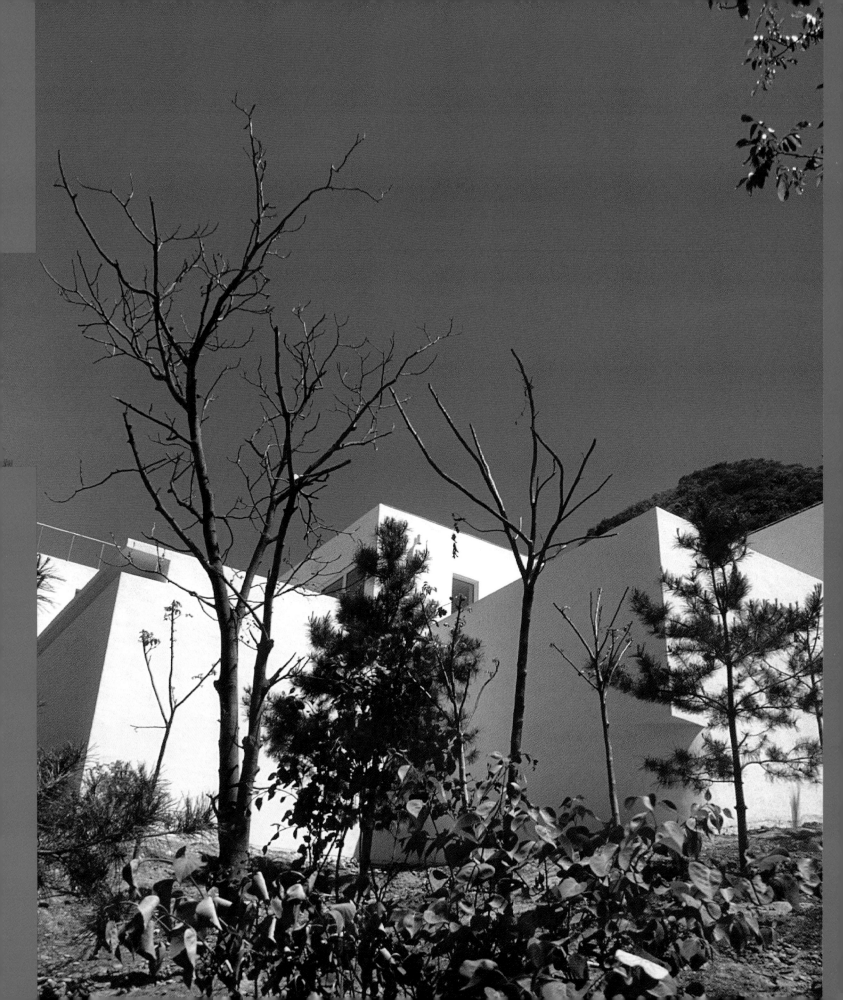

Kanika R'kul is one of the most outstanding young emerging architects in Southeast Asia. Born in 1962 in Bangkok, she completed a Bachelor of Art in Interior Design at Southern Illinois University, USA. She then went on and earned a Master of Architecture from The Southern California Institute of Architecture (SCI-Arc).

Her participation in The Commune by The Great Wall project translated into her work known as "The Shared House." According to Kanika R'kul, China has entered into an era of modernity, which is represented by a western thought model as well as an era of post-modernity. Such post-modernity is represented by an attempt to reconcile internal emergence and external influence. The house in this context, according to the architect, attempts to fulfill the need for its users to create "connections." The connection between inside and outside or between human and nature, is created with outdoor spaces such as terraces, courts, and roof decks. The connection between people is created by emphasizing the importance of communal space, such as living and dining rooms versus bedrooms. Bathroom areas are experimentally approached as communal rather than (traditionally) private domains, in an attempt to confront the traditional notion of public versus private. The site where The Shared House stands is symbolically strong. For the architect, the mountain range is visually inspiring, as well as physically challenging. The house addresses the site through its scale, form, orientation, and placement of openings. From various spaces of the house, the site is being perceived in different portions and scale. The architect approaches the house as sequences of space that are not intended to be understood in an instant. Each space offers an encounter between man-made and natural at different portions and scales. These encounters are illustrated from different angles, such as the quietness of the entry court, and the sky to the extension of the dining, living, and sitting areas out into the main terrace and the valleys below. ❮❮

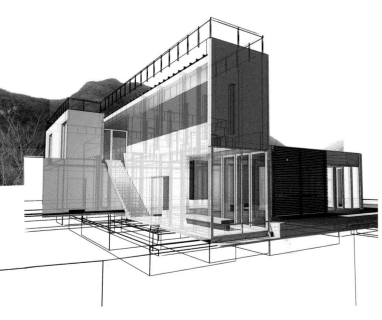

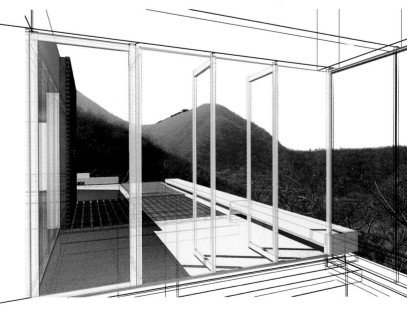

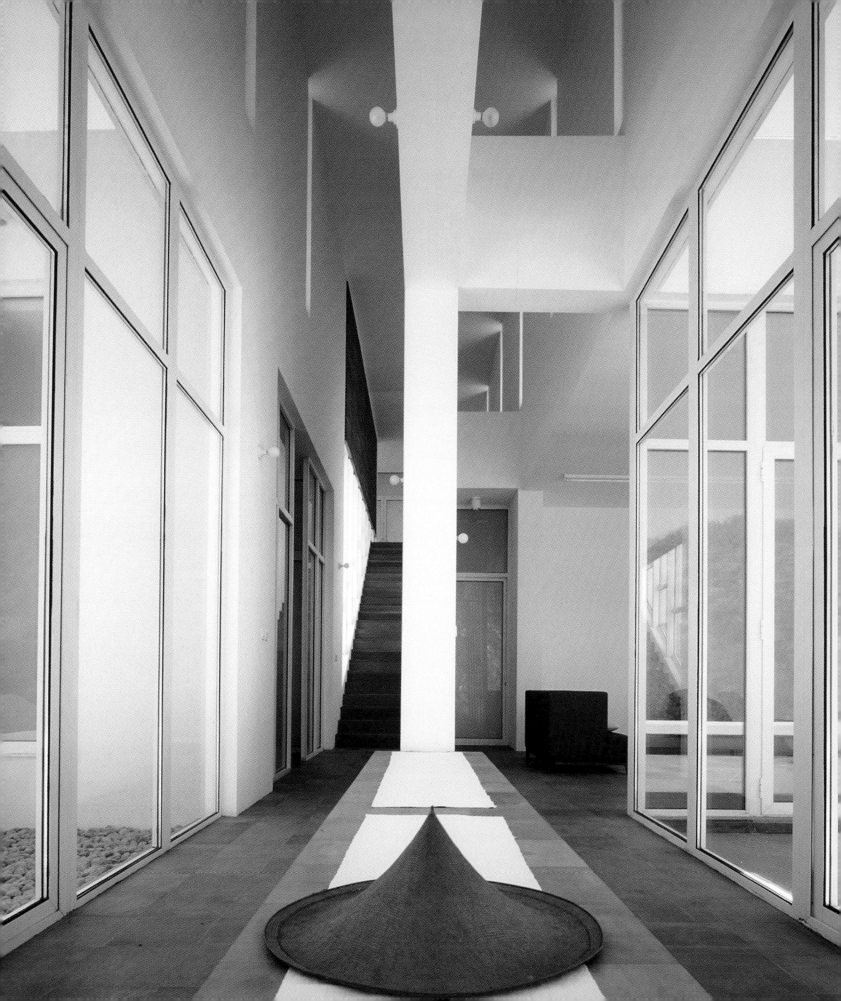

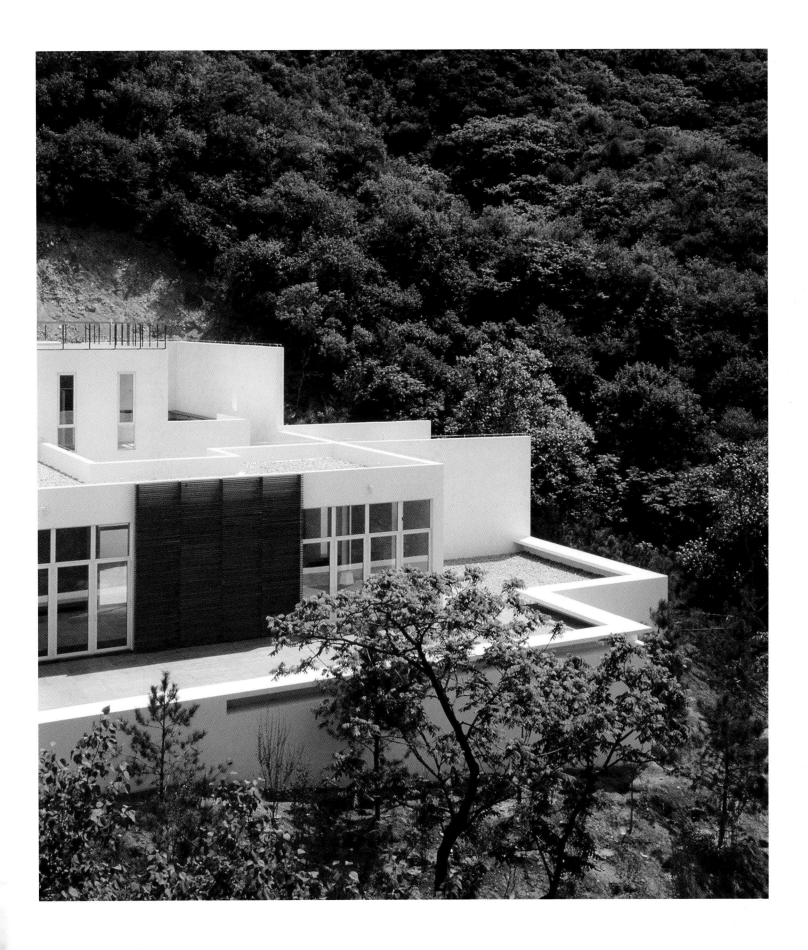

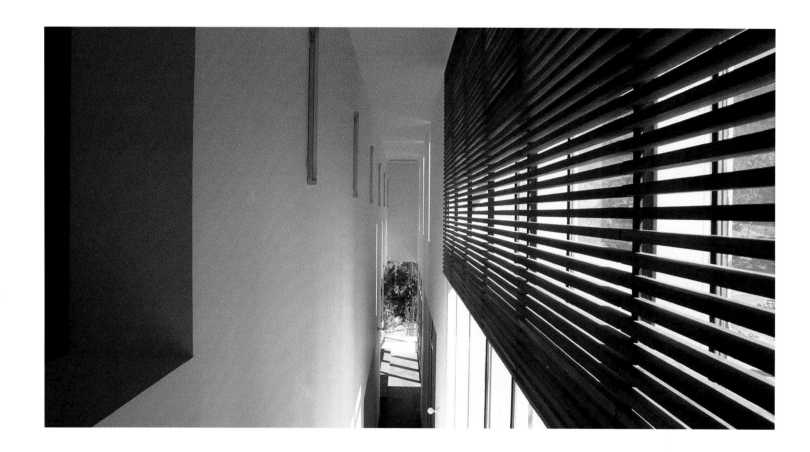

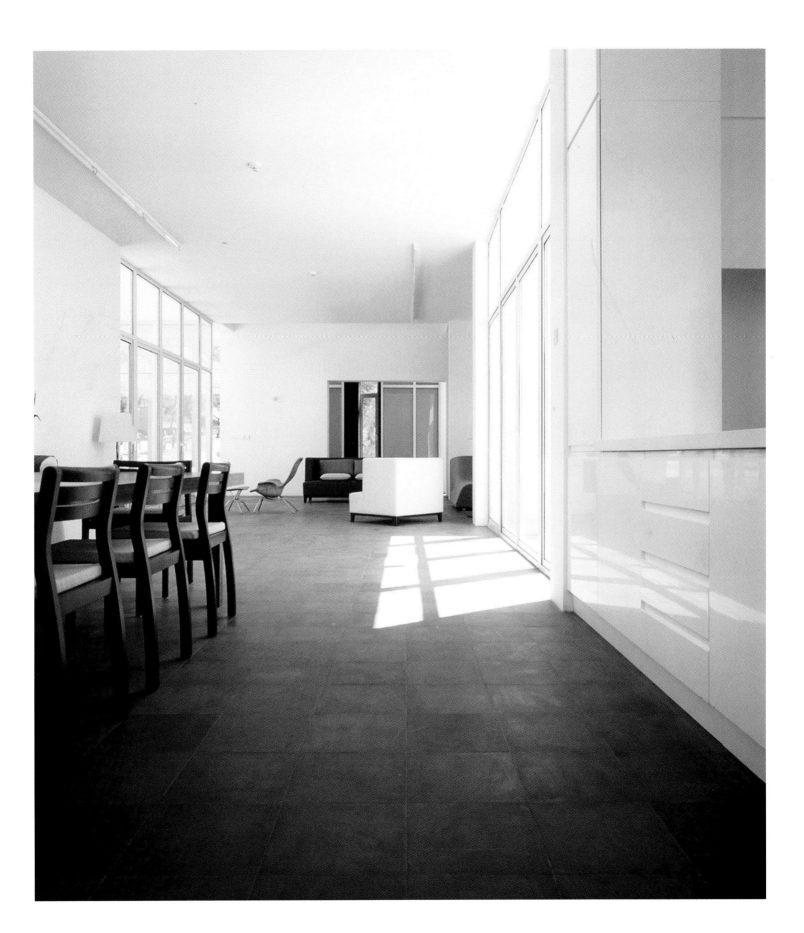

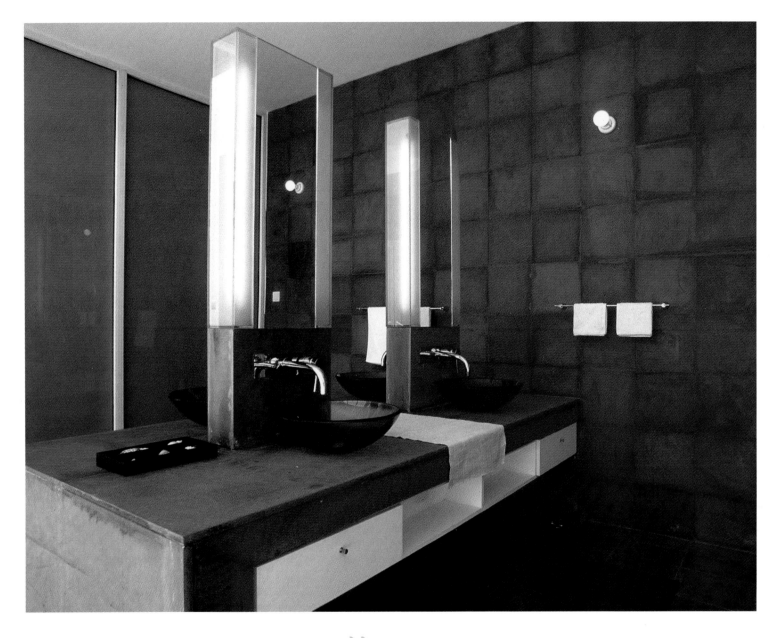

>> A repetition of color and form provides a minimalist atmosphere.

Casa Sala

Tonet Sunyer
e-mail: **tsunyer@arrakis.es**

Completion date: **2000**
Location: **L'Ametlla del Vallès, Barcelona, Spain**
Floor Space: **3981 ft²**

Photographer: **Hisao Suzuki**

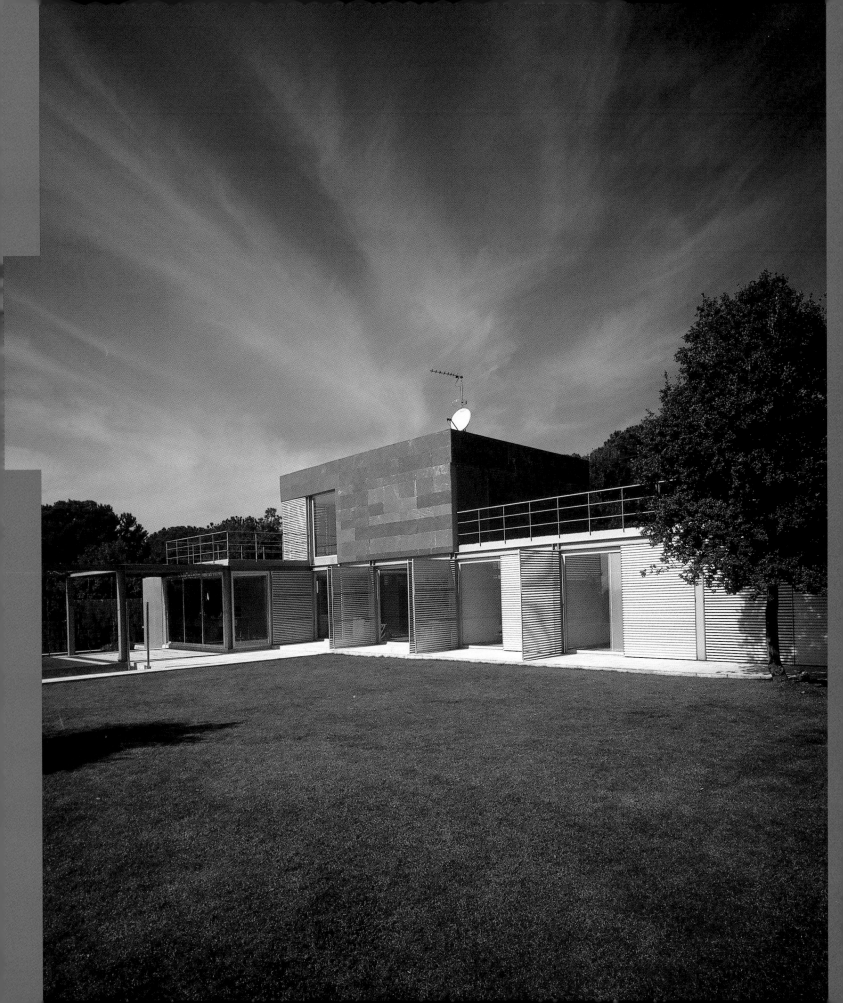

Tonet Sunyer was born in Barcelona, Spain in 1954. Not very long after he graduated in architecture from L'Escola d'Arquitectura de Barcelona, he was already awarded with the FAD prize in Interior Design for his work known as "Joyería Berao." Later on, in 1989, he was subsequently awarded, again, with the FAD prize in architecture for his project "Casa Nassia." From then on, he has continued to receive numerous prizes, as well as much credit as a lecturer and a professor at various universities, mostly in Spain and Italy.

Casa Sala, located on a trapezoidal piece of land, is situated in a small town near the Barcelona metropolitan area. The site where the building stands slopes 20 ft in its direction, North-South. The dwelling is organized in a linear manner on its East-West axis, perpendicularly crossed by a horizontal plane formed by a pergola housing the garage and a gymnasium. A swimming pool lies parallel to the pergola. From the street, a terrace and a rectangular area with a black slate finish are clearly visible, indicating the access to the building. The entrance to the house is seen on the level which incorporates a studio-library, from where, descending through a staircase, the dwellers reach the hall and the various rooms of the house. Cars slope down a ramp to reach the garage. The living room and the bedrooms face a garden situated at the southern part of the plot (on a 10 ft level), which enjoys plenty of sun and nice vistas. The kitchen, argues the architect, as the center point of the house's summer life, was positioned, at the owner's request, in a privileged location which faces the pergola and connects to the garden. At a 20 ft level lies the guestroom, totally independent from the main garden and the house itself. As contended by Josep Maria Montaner, Tonet Sunyer creates an architecture wisely adapted to each particular location or environment, to its topography, materials, and culture. ≪

>> DIRECT AND PURE

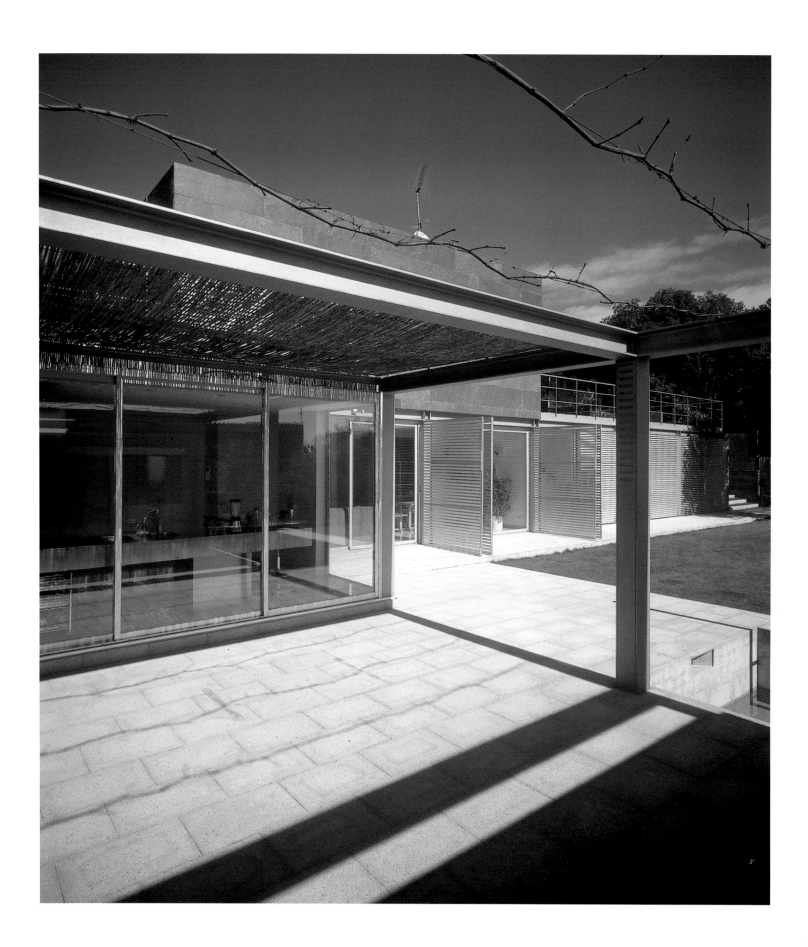

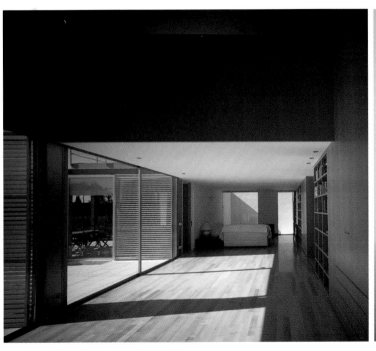
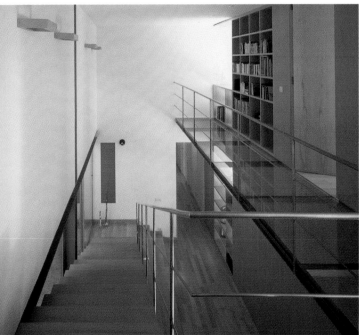

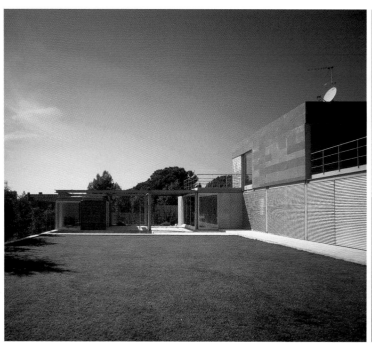 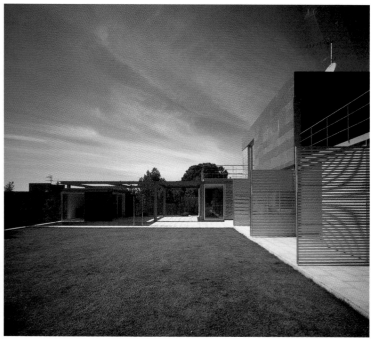

>> Flexible openings seem suitable for the Mediterranean climate.

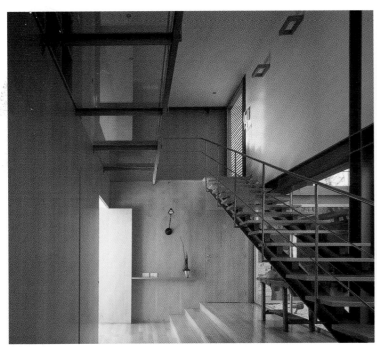
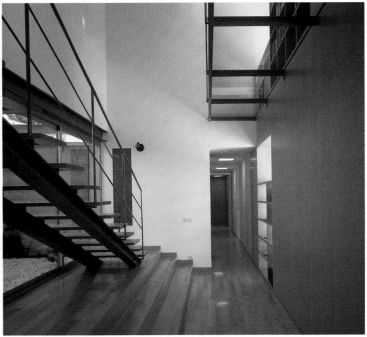

The light and sharp design of the stairs give added rhythm to its inner space.

ptw Architects

Ryan
Apartment

PTW Architects
e-mail: info@ptw.com.au
url: **www.ptw.com.au**

Completion date: **2001**
Location: **Sydney, Australia**
Floor Space: **1468.74 ft²**
Photographer: **Sharrin Rees**

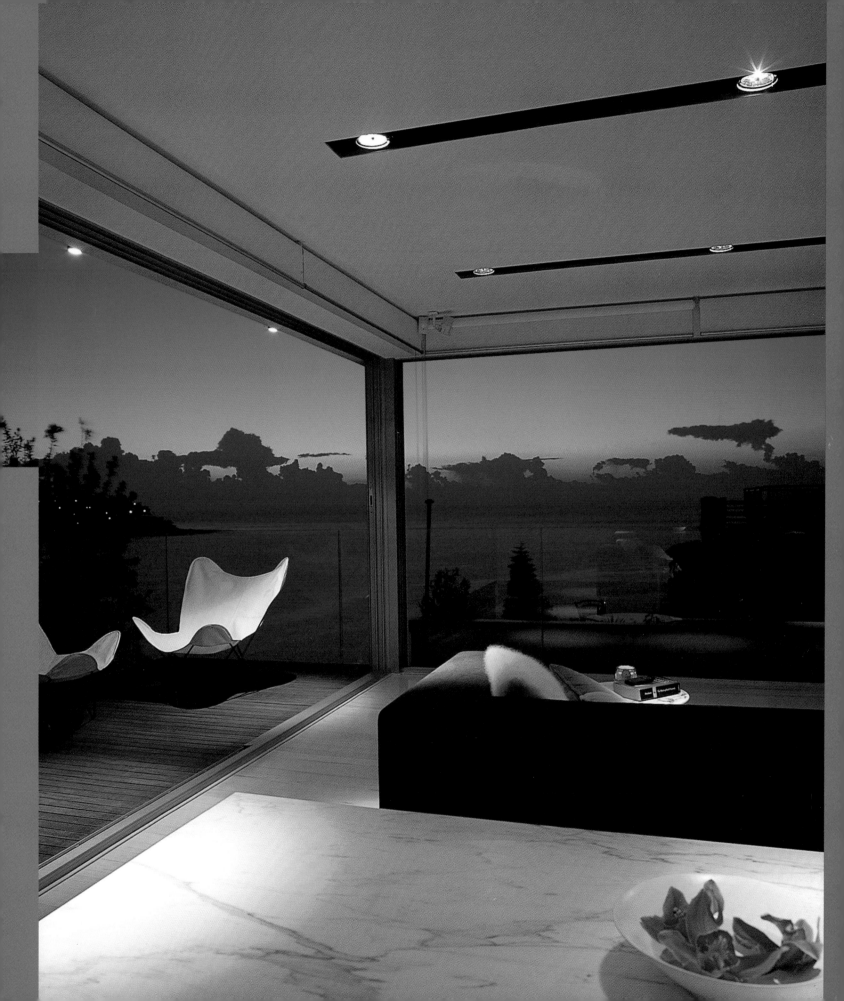

James Peddle, the founding member of the firm that was to become PTW Architects (PTW), arrived in Australia from England in 1889 when Sydney was a colony of 350,000 people. More than a century later, along with the evident growth of the city, PTW has grown from a one-man practice to one of the largest and most diverse architectural firms in Australia and the Pacific Region. The firm, currently employing approximately 150 people, has offices in Sydney and Beijing, as well as a number of associated offices around the world since the late 1980s. Areas of expertise include Sports and Olympic projects, Residential Architecture, Cultural, Health, Master planning, and Interiors.

As for the Ryan Apartment, the Interior division of PTW Architects overhauled the interior of an old apartment dating from the 1960s in search of a more efficient organization and more modern look. Most of the interior walls were knocked down, making way for the new layout, which unified the different parts of this dwelling. The sitting room is marked out by a series of sliding doors; these, together with the balustrade (also made out of glass) make it possible to enjoy views of the popular Bondi Beach from inside the apartment. White is the dominant color in all the rooms, providing a neutral counterpoint to the fascinating panoramic vistas and the design furniture that enhances the space. According to PTW, its approach is to analyze each architectural task and produce a distinctive and creative design solution. With the Ryan Apartment, PTW achieves this by encouraging innovation and initiative to their team of designers, but always with the overall objective of architectural excellence, efficiency, and cost-effectiveness that has become the firm's trademark. ≪

>> PERFECT USAGE OF WHITE

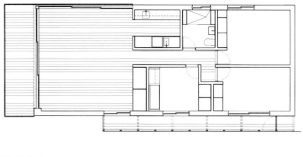

Floor Plan

0 1 2

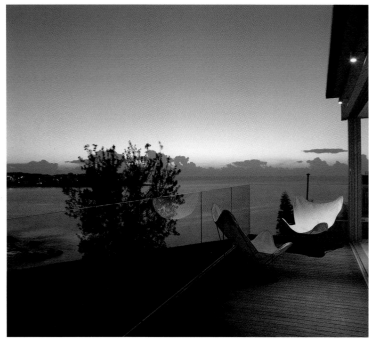

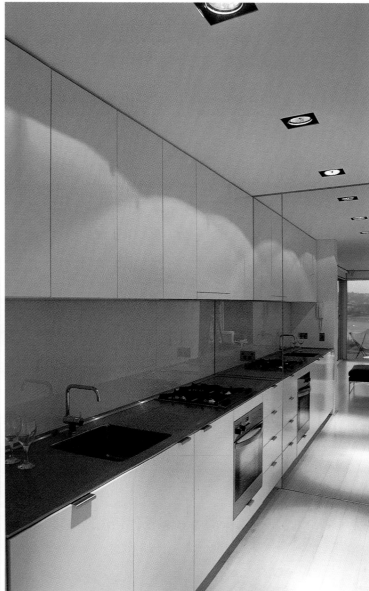

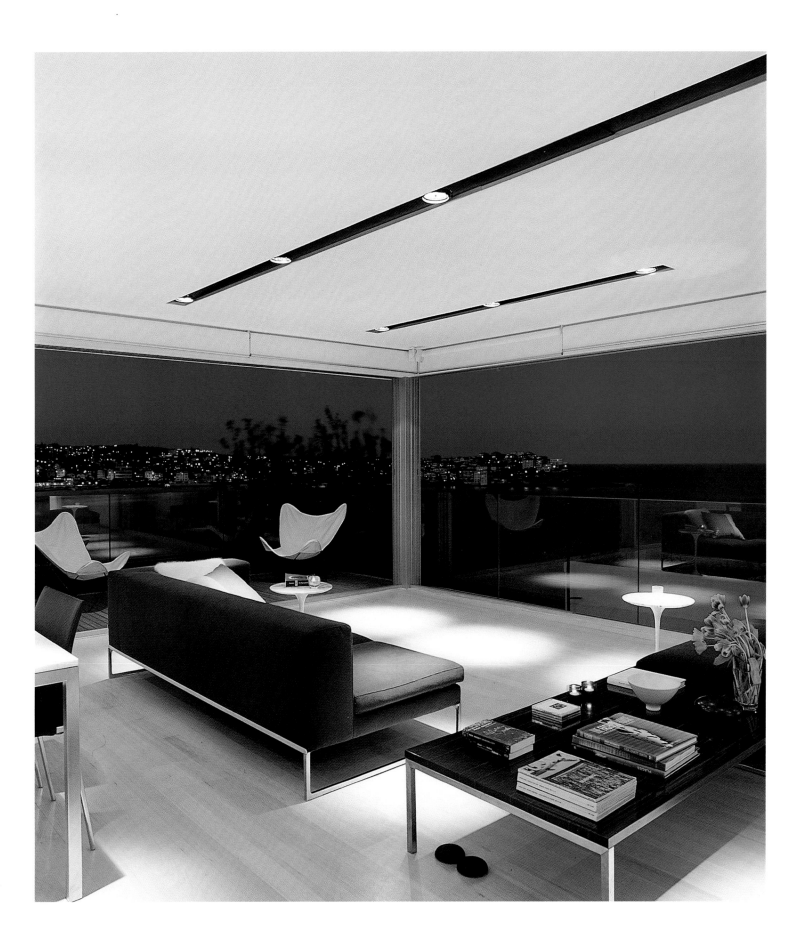

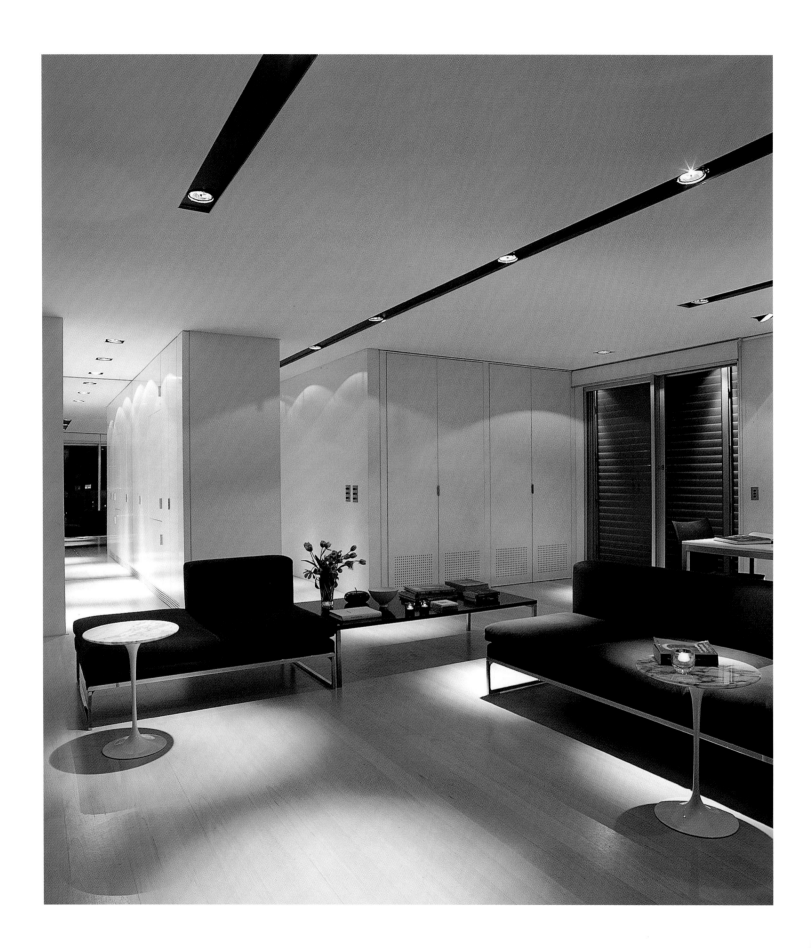

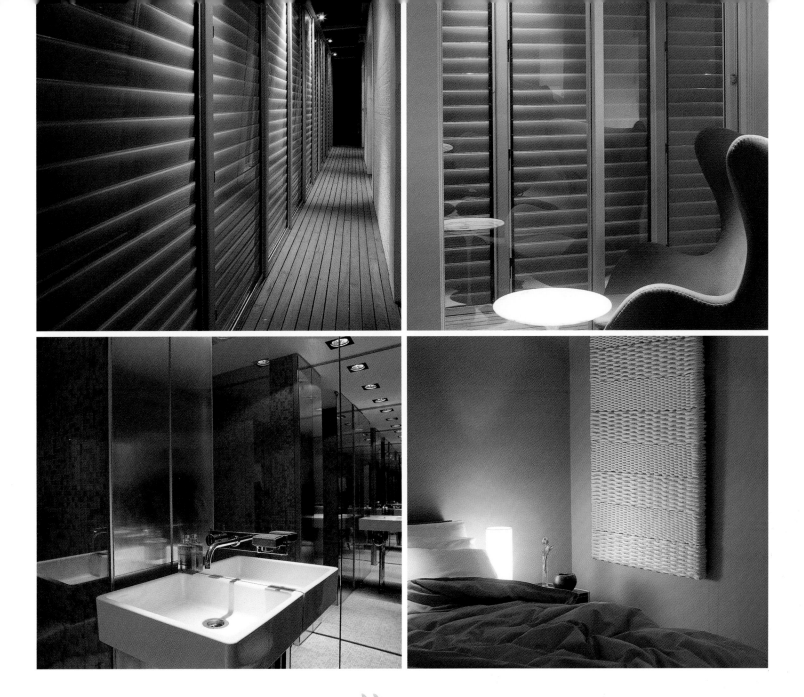

>> Abundant storage space designed to create an orderly impression to its interior.

Jacques Moussafir

Stein-
Fleischmann
House

Jacques Moussafir / Moussafir Architectes Associés
e-mail: moussafir.archi@wanadoo.fr

Completion date: **1998**
Location: **Suresnes, France**
Floor Space: **2044 ft²**

Photographers: **Nicolas Borel / Gilles Walusinski / Joël Cariou /
Jacques Moussafir**

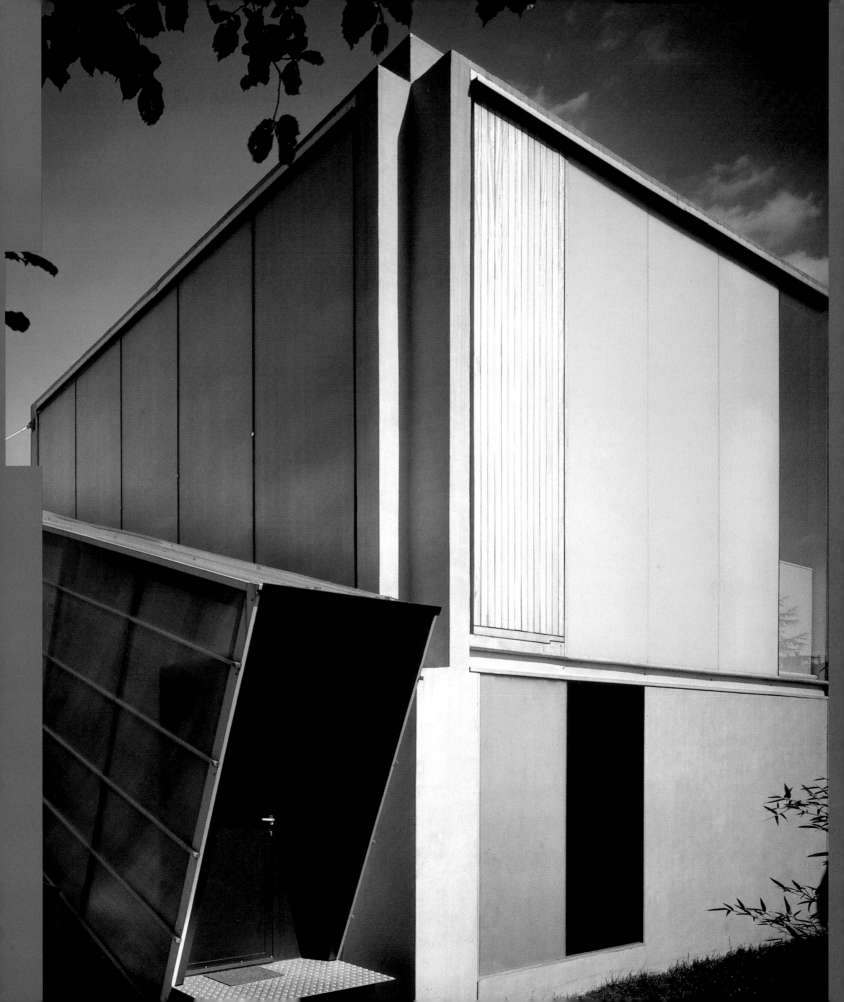

Jacques Moussafir, born in South Africa in 1957, spent part of his childhood in Greece and England before settling in France. After obtaining a degree in History of Art from the University of Paris, France, Jacques Moussafir worked in the offices of some of France's best-known architects, including Henri Gaudin, Christian Hauvette, and Dominique Perrault. By the mid-1990s, Jacques Moussafir had set up his own practice and designed a school of the arts at the University of Saint Denis that brought him international attention.

The Stein-Fleischmann House, situated in Suresnes, France (an affluent suburb just three miles west of Paris´ Champs-Elysées) is composed of two parts: a cubic pavilion that runs parallel to the street and a wing that connects it to the front building. The front wing stigmatized by this heterogeneity, according to Moussafir, is the "morphological transition from a block into a pavilion tissue of clean-lined volumes."

Built for a young couple and their two children, the house divides itself into a functional stratification of spaces, those dedicated to reception and sociability, and those dedicated to resting and to introspection. In its lower level, the space is full of color, both horizontally and split up. The space is defined by the limits of the garden. The whole house is crossed by axis of light and vision into the exterior. At every transition of space, as well as every door-step, the eye finds an escape into the exterior of the building. In its upper level, a white, ample, and bright space full of light develops in strict geometry. Seven large picture windows provide distant and fragmented visions to its dwellers, centering oblique and vertical views of the neighboring buildings´ silhouette. Both understood as a refuge, and a platform from which to observe the suburbs and its gardens, this cubical space is oriented according to the four cardinal points. The architect argues that the views from the house are like a kaleidoscope facing the sky and transforming the surrounding banality into a collage of a transfigured reality. «

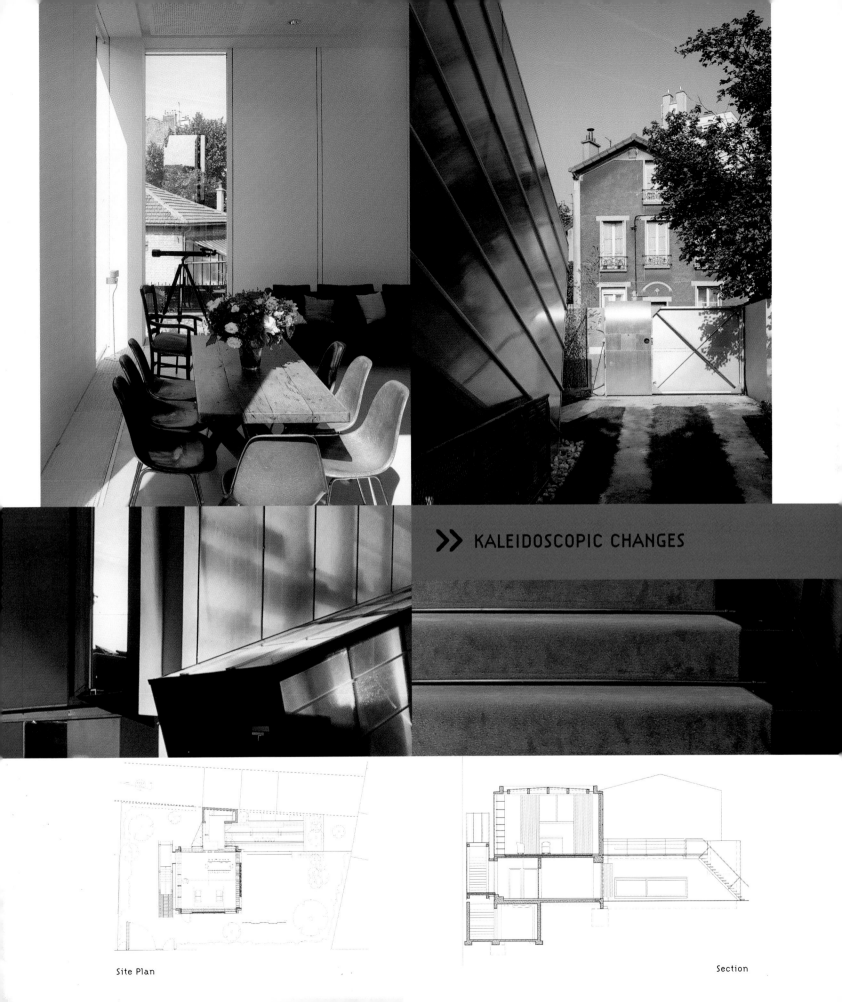

>> KALEIDOSCOPIC CHANGES

Site Plan

Section

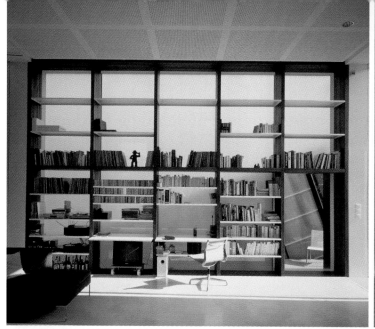
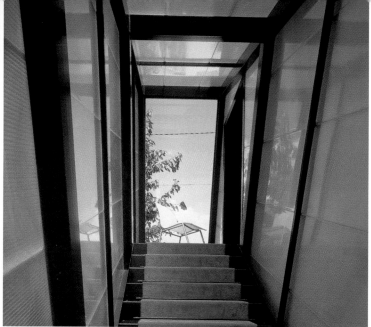
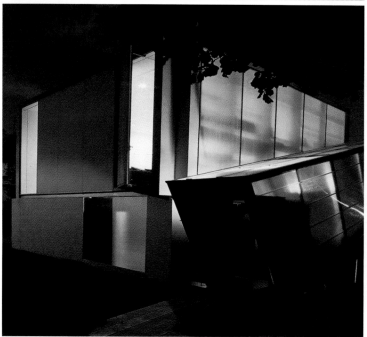
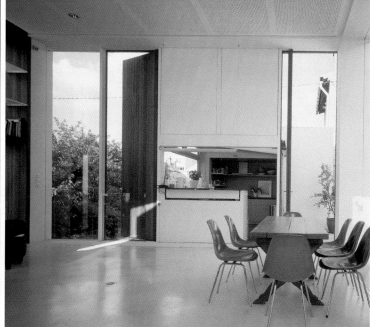

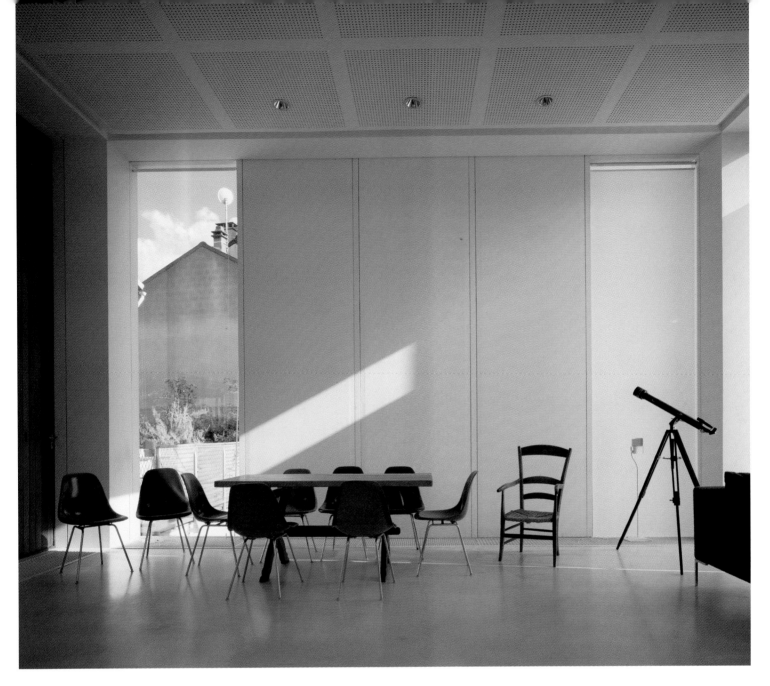

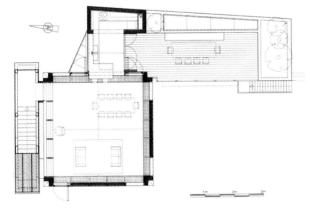

Second Floor Plan

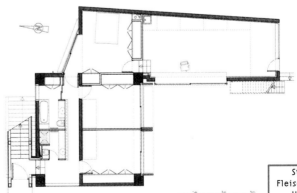

First Floor Plan

Stein-
Fleischmann
House

155

A-cero

House in Madrid

Joaquín Torres Vérez / a-cero estudio de arquitectura y urbanismo
e-mail: a-cero@terra.es

Completion date: 2001
Location: Madrid, Spain
Floor Space: 26900 ft²

Photographer: Hisao Suzuki

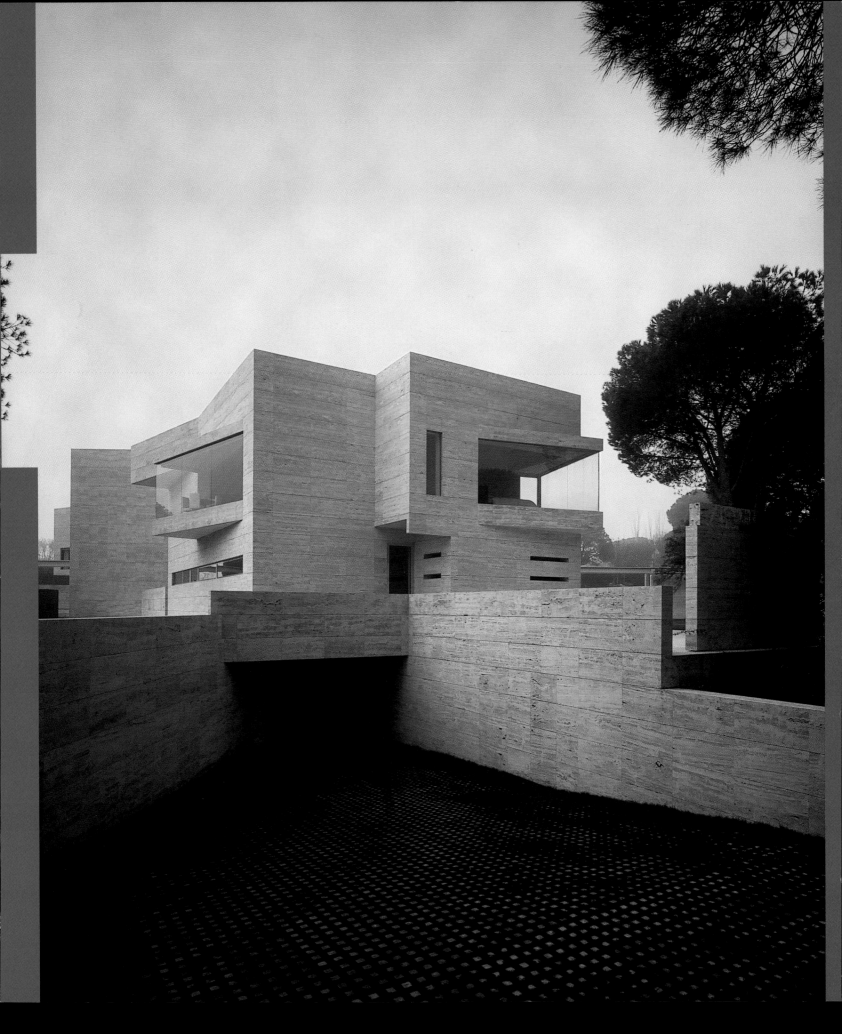

The architectural studio known as a-cero estudio de arquitectura y urbanismo was created in 1996, its core activity being the integral development of architectural projects. The a-cero team, lead by Joaquín Torres, continues to increase since its start, and they now have offices in Madrid and A Coruña, Spain.

Their House in Madrid is located on a slightly rectangular plot of land on 2.5 acres. Built on the eastern side of the lot, the building is structured on two axes that meet at an oblique angle. The first axis, following the direction North-South, organizes the different rooms based on a number of macle volumes that give structure to its various inner and outer spaces. The second axis, mainly a porch area, stretches in an East-West direction and regulates the relationship of the building with the exterior space of the house. Inside, the different levels are divided by the prisms created at the crossing of the two axes. On the underground floor level, these diamonds mark the division between the garage area and the play area. The slope of the plot of land allows for each floor level of the building to gain direct access to the exterior of the house.

The structural scheme stresses the purity of forms of this building. Thus, the structure is exclusively composed of reinforced concrete walls and flagstones that distinguish the various outlines of the house. All intermediate pillars are removed that would alter the scale of its inner space. According to a-cero, "This is undoubtedly an architectural project developed in all its facets and scales, from its urban aspect to every minor construction detail, going as far as to design the very own pieces of furniture to be placed into the dwelling, thus reinforcing the inherent idiosyncrasy of the space as a whole." «

>> PURITY OF FORM

First Floor Plan

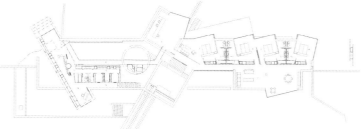

Second Floor Plan

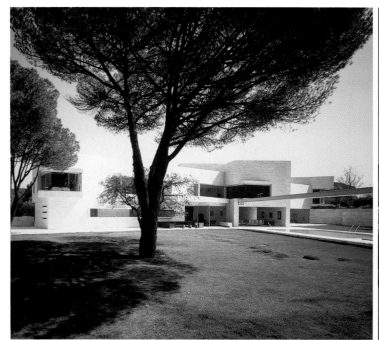

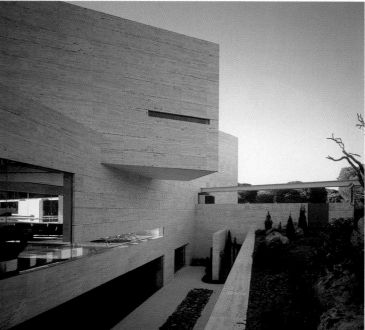

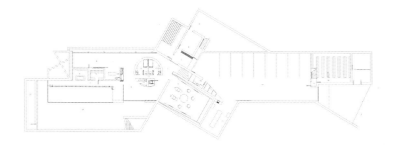

Third Floor Plan

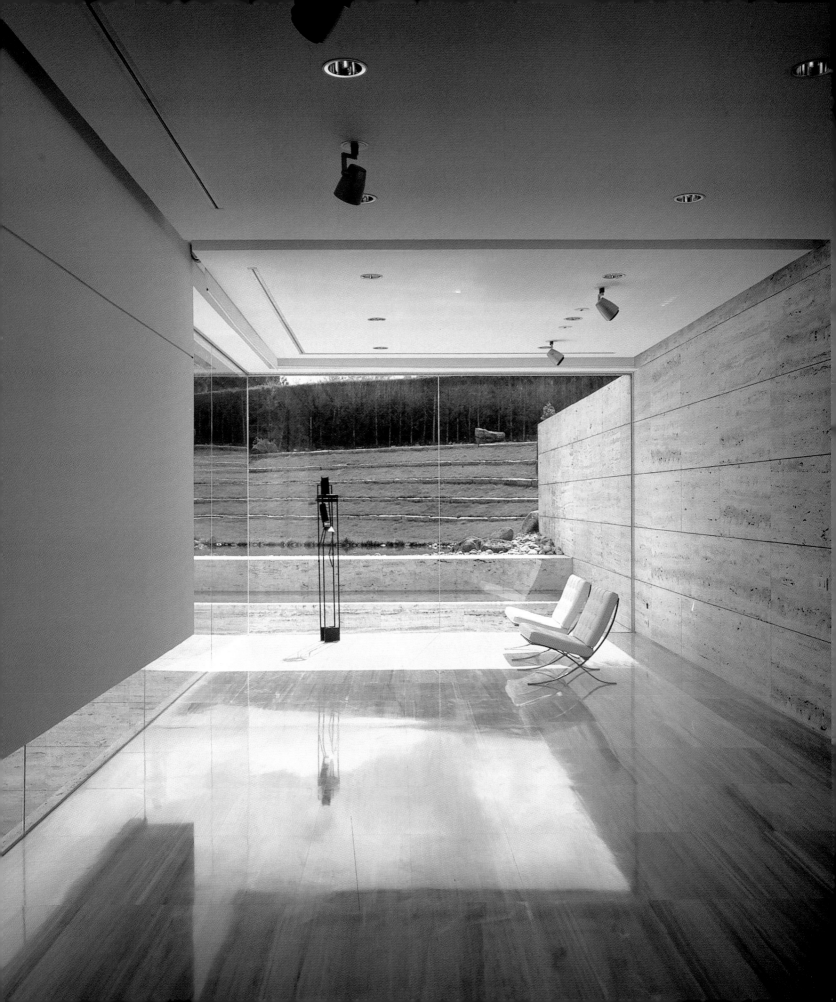

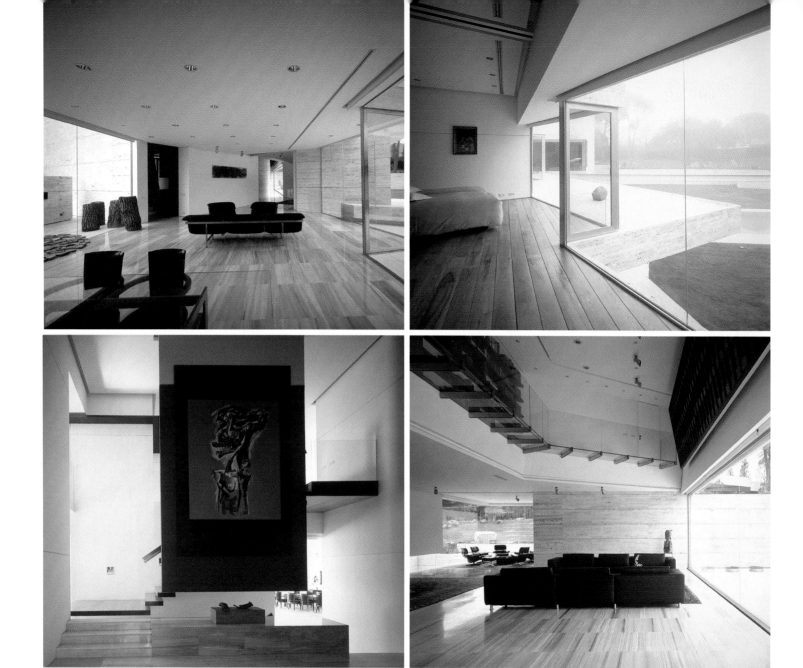

>> An effective combination of geometric forms with glass and natural materials.

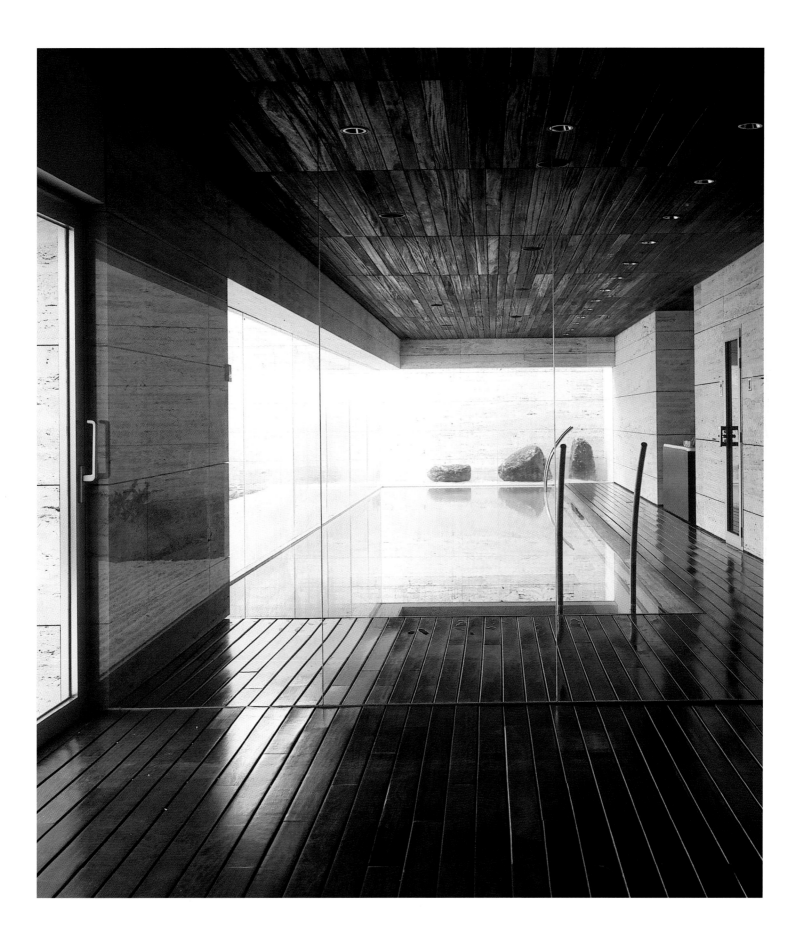

Carlo Donati

Loft
A

Carlo Donati
e-mail: carlodon@tiscalinet.it

Completion Date: **2002**
Location: **Milan, Italy**
Floor Space: **3340 ft²**

Photographer: **Mateo Piazza**

The basis for this project is the typical, traditional Milanese house with a balustrade. The concept of the space, is the union of the three units which comprise it. Originally, the space was divided up into two small apartments, one on the top floor and the other on the bottom floor. The one on the bottom floor was connected, by means of a corridor, to a spacious area which served as an art gallery.

The entrance hall was transformed into an ovoid-shaped area where two geometrically pure bodies insert themselves into each other, thus creating different directions. A spiral staircase emerges from the first volume in a quest for fluidity between the old and the new space, and connects it to the bedrooms on the second floor. The second body leads us to the master bedroom which is converted into a complete, independent room with a bathroom, wardrobe and direct access to the interior of the garden.

The rooms on the first floor have interior and exterior spaces and receive direct natural light. Among them is the kitchen which acts as a kind of filter between the entrance and the rest of the house. The dining room has a large table for ten people. It is the leisure area where we can enjoy conversation or engage in other social activities. It is complemented by the living room which occupies the old art gallery.

Avant-garde technology was used. For example, the heat panels in the floor provide a heating system which is very common in Northern European countries. The electrical system provides maximum lighting flexibility, which was a basic premise of the project. You can control the lighting automatically and remotely by means of a cell phone or a computer. The materials used are also an important part of the architectural and structural concept. For example, some structures are made of carbon fiber and the flooring is covered with a resin material. The original parquet floor was only maintained in the bedroom. In the kitchen they made ample use of paneling which is natural wood from South America. «

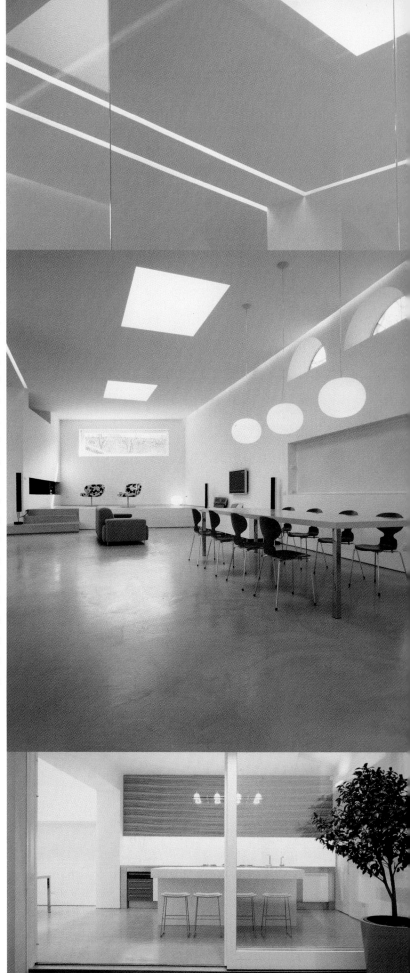

>> AVANT-GARDE TECHNOLOGY

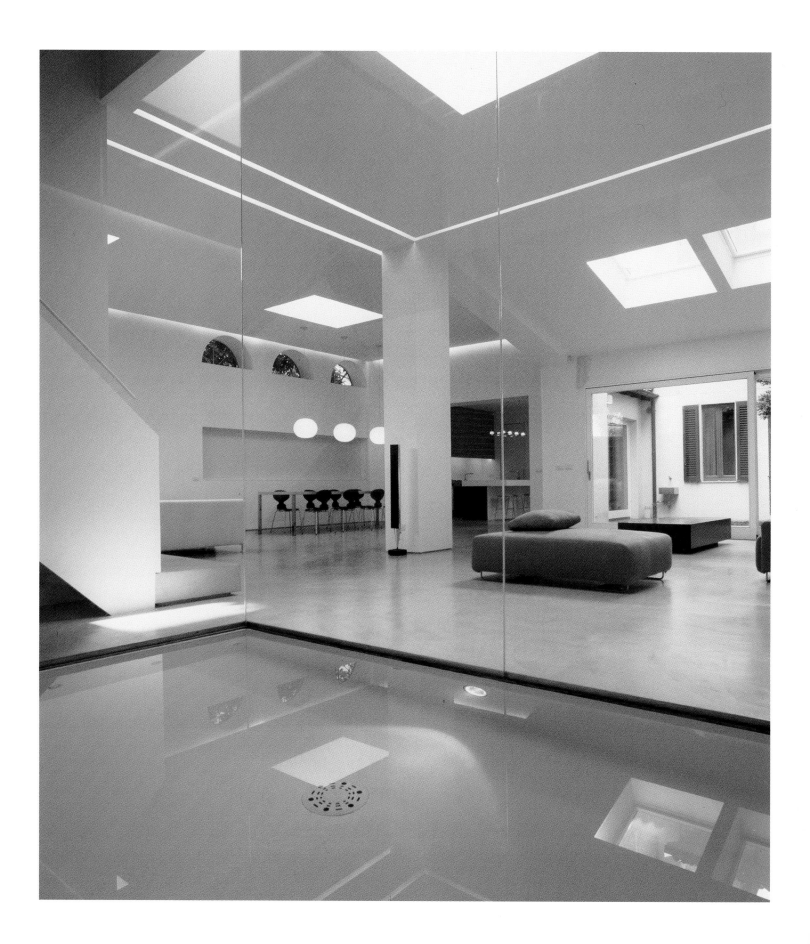

First Floor Plan

0 1 2

>> A good example of how to use vivid colors to give a special touch to this minimalistic space

Second Floor plan

Loft A

169

WARO KISHI

House in Fukaya

Waro Kishi + K. Associates/Architects
e-mail: kishi@k-associates.com
url: www.k-associates.com

Completion Date: 2001
Location: Fukaya, Saitama, Japan
Floor Space: 2042 ft²

Photographer: Hiroyuki Hirai

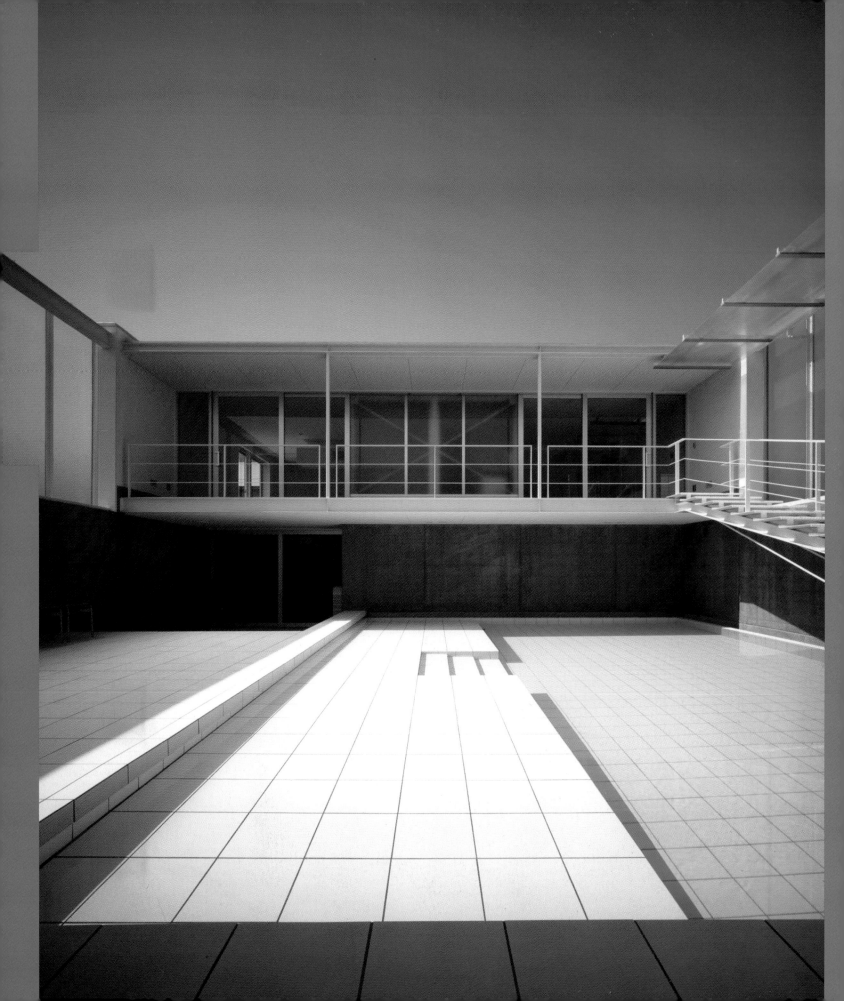

Waro Kishi (1950, Yokohama, Japan) has his studio based in Kyoto. A graduate of Kyoto University, he is now a professor of the Kyoto Institute of Technology. Featured in monographs recently published in Europe, Kishi's works are also highly appreciated around the world.

This house is located in Fukaya in the Saitama prefecture, on the north of the Kanto plain. Despite its proximity to metropolitan Tokyo, the site chosen is in an area very often described as a "city suburb." As for the location, the architect chose a closed configuration, while keeping an open interior space. The house has a rectangular plan, measuring 31.5 ft east to west and 76.8 ft north to south, thus forming a three part function. The southern part contains the private elements, the garage and bedrooms, on two levels. The northern part, which is a half-level higher than the rest of the structure in elevation, contains the living/dining area, a large space with a ceiling height of 15 ft. A courtyard with a pool is located in the center of the building. The courtyard serves to connect the southern and northern parts while also functioning as an exterior living room, for it is designed to unite with the living/dining area. To give the courtyard continuity with the living/dining area, the architect sought to minimize the dimensions of the intervening structures.

By placing the horizontal force on the exterior wall structure, Kishi was able to use 2x4 inch posts. The glazing is attached directly to these posts, so that they are free from sash windows, as well as from the wall structure. By using factory materials and leaving the structural details visible, the building displays real architectural character. The architect felt that the best way to confront the stark surroundings was to present a space that wasn't replete with the warmth of congenial material, but rather with an aggressive deployment of materials and structures that proliferate in the surrounding areas. ≪

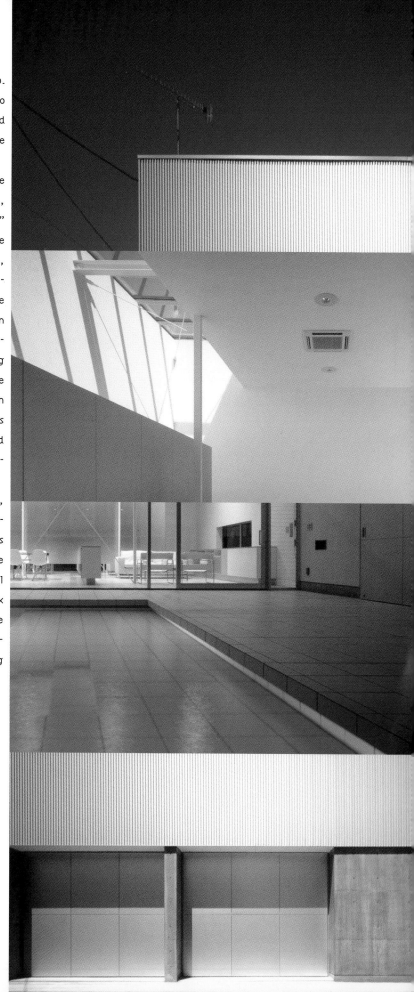

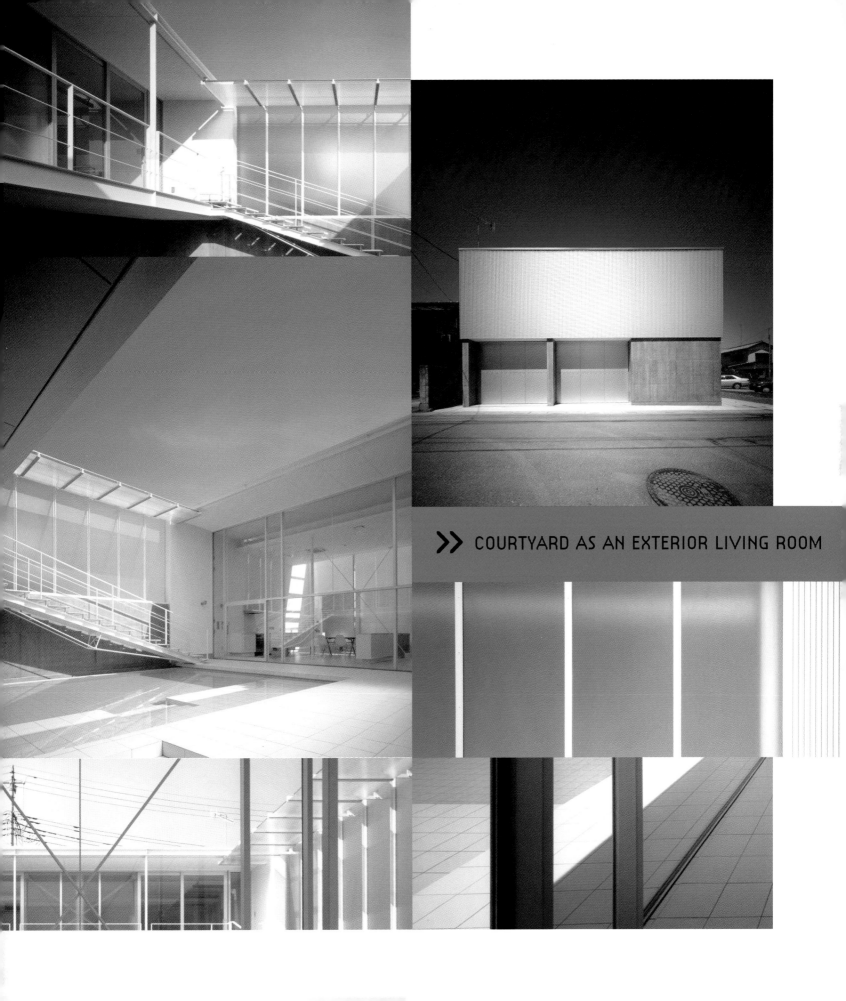

>> COURTYARD AS AN EXTERIOR LIVING ROOM

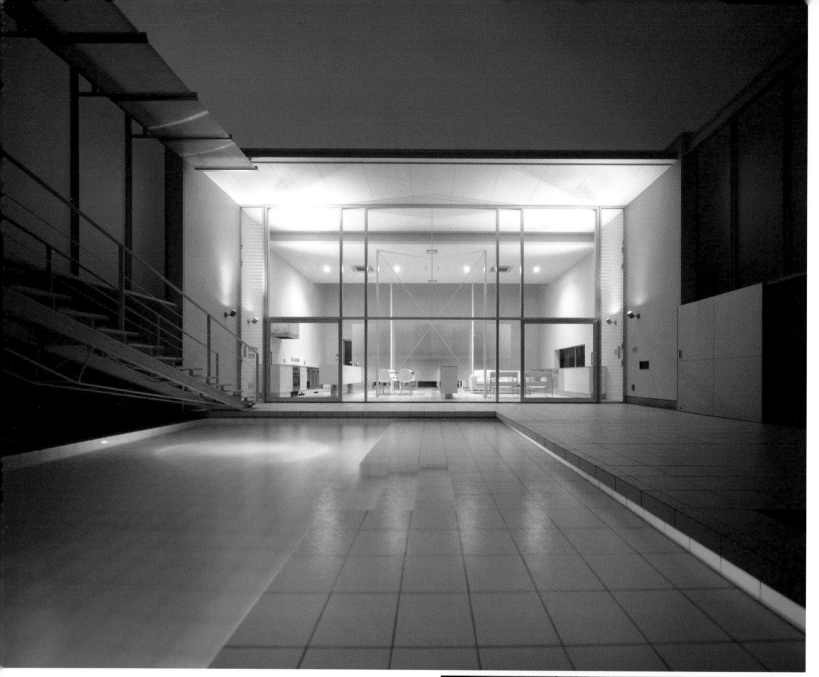

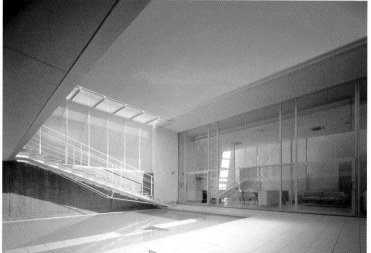

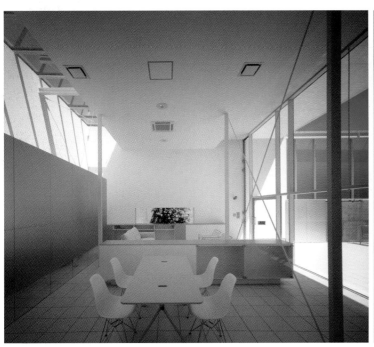
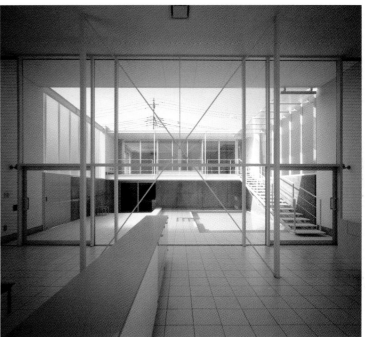

» To confront its stark surroundings, industrial materials are used and the structural details are left visibly exposed.

>> MNM